Native American Art
M A S T E R P I E C E S

Native American Art
MASTERPIECES

David W. Penney

Hugh Lauter Levin Associates, Inc.

Design by Ken Scaglia
Editorial Production by Deborah Teipel Zindell
ISBN 0-88363-496-1
Printed in China

Contents

Acknowledgments

Once again I want to thank Hugh Levin for this second opportunity to work with the talented and capable staff of Hugh Lauter Levin Associates. Our first collaboration, *Native American Art,* has been out for little more than two years. Ellin Silberblatt lent invaluable assistance, leading the team once again through the process of producing the book. Deborah Zindell helped greatly during the preparation of the manuscript and sorted out editorial problems with elegance and delicacy. I also wish to acknowledge and thank George Longfish for his selection of works of twentieth-century artists for the first book from which this volume benefits. Thanks also to Kay WalkingStick, whose work and subtlety of thought inspired, to a large degree, the direction of the introductory essay.

I dedicate this book to my wife, Jeanne, and my children, Hilary and Joel.

Reading the Signs

European-derived philosophies refer to "art" as common to the "family of man," as a kind of human universal in which the capacity for individual creativity transcends cultural content. It is not possible, however, to comprehend the significance of American Indian art without, to some extent, entering into culture, into a context of creativity that has origins entirely independent of the philosophies of art of European origin. The North American continent has nurtured countless generations of men and women. Its mountains, lakes, and forests witnessed with mute testimony the frail activities of the human beings who struggled against its challenges and rejoiced for its gifts. Long before visitors from across the ocean "discovered" North America, Native North Americans had experienced the rhythms of an ancient cultural history and developed a complex philosophical tradition to make sense of it.

Culture, a community's ways of organizing itself and reconciling its relationships with the earth, is always and inherently unique. Although cultural practice is often conservative and time honored, it is also flexible and adaptive to unexpected opportunities and challenges. Culture is, for the most part, determined by language. Language is the system of signs by which the community organizes and understands the world in which it lives. Every perception, every thought, is filtered through it. Language is fundamental to the creation of an ideology and inversely, ideology shapes language. Verbal language is most important in this regard. The language of words is the most refined tool for social integration, allowing communication of complex ideas with great specificity and precision. While kinship to a large degree determines community affiliation, language defines ethnic identity. When speaking of the Lakota people or the Ojibwa people, for example, one is speaking of those who speak the Lakota or Ojibwa language.

In addition to the language of words, there is also a visual language, a language of signs that can be perceived in every variety of thing. The experience and perception of the natural world is replete with visual signs: the track of an animal that signifies its passing, the changing color of leaves that means the approach of winter. Language assigns everything observed in the environment a meaning that is cultural, an interpretation of its significance that helps to explain the way the world works. The European philosophical tradition, a system of observation and deductive interpretation that has been refined over a period of many centuries, is the basis of modern, empirically based science. But for cultures with very different ideological origins and traditions, such as the cultures of Native Americans, the world of visual signs can be interpreted in very different ways.

Within a universe that reveals itself largely through visual experience, the things that people make also possess the ability to convey meaning. Visual language, then, lies at the root of "art," which releases its expressive power through symbol, metaphor, or mimetic effigy. Visual signs employed in Native American art can convey information in a very explicit fashion, like the war records that are painted on Plains men's buffalo robes and other garments, or they can be left purposefully ambiguous, allowing for freer interpretation, as in the nature-based designs painted by women on Pueblo pottery.

It is important to begin with the notion of visual language when approaching the topic of American Indian art because "art" as a category has no meaning within the strictly Native world view. This is not to say that

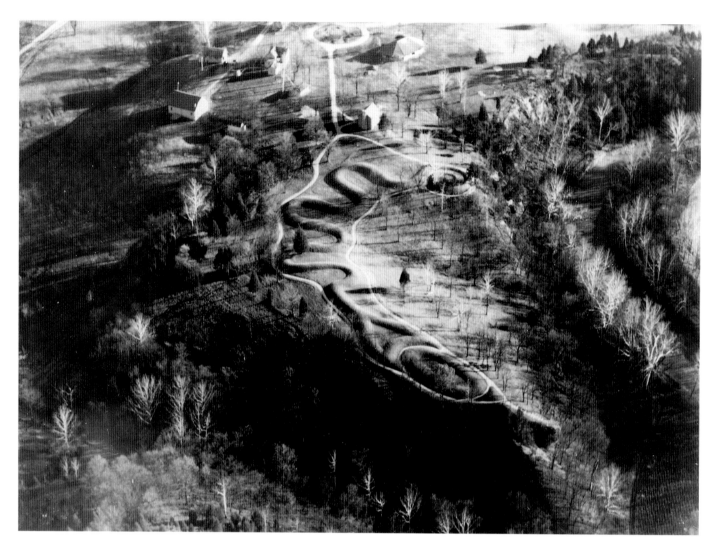

SERPENT MOUND. Adena Culture. Adams County, Ohio.
This unique earthwork was constructed by an ancient Native American culture at least two thousand years ago. Its unknown symbolic purpose was undoubtedly related to burial mounds located close by. Photograph courtesy of the National Archives of Anthropology, Smithsonian Institution, Washington, D.C.

Native American people did not make objects that can be understood as art today. But in Native languages there was no single term for a unique category of object or practice that was intended to isolate aesthetic experience as there was in the art traditions of Europe or the Orient. In Native cultures, the "aesthetic" value of an object derives from its significance within a system of visual language. Care in craftsmanship, mastery over technique, inventive and dynamically conceived design—all the factors considered when evaluating the formal properties of an object—possess important cultural significance as well, such as the love for family expressed in the creation of an elaborately decorated set of regalia, or the intensity of spiritual experience conveyed in the painting on a war shield.

Efforts over the last century to reclassify objects made by Native people as "art" have been based on the European notion of art, which developed within its own system of visual language and signification. Thereby, the Native significance of objects is obscured in favor of questions and issues that are alien to it. In fact, to write about Native American art history is to discuss a body of work from a perspective that is foreign to its culture. The best one can hope for is a successful act of *translation,* an accurate interpretation of what Native visual language conveys across the boundaries of culture.

It is customary, perhaps, to think of the art "masterpiece" in purely aesthetic, formal terms, as an object that demonstrates mastery over technique and effect. The idea of the "masterpiece," like the concept of "art" itself, stems from Eurocentric traditions of art making. The objects selected for this book certainly fit this criteria, illustrating the great range of technique and media over which these individual artists achieved consummate mastery. The additional factor for selection here, however, stems from an object's symbolic eloquence as a masterful

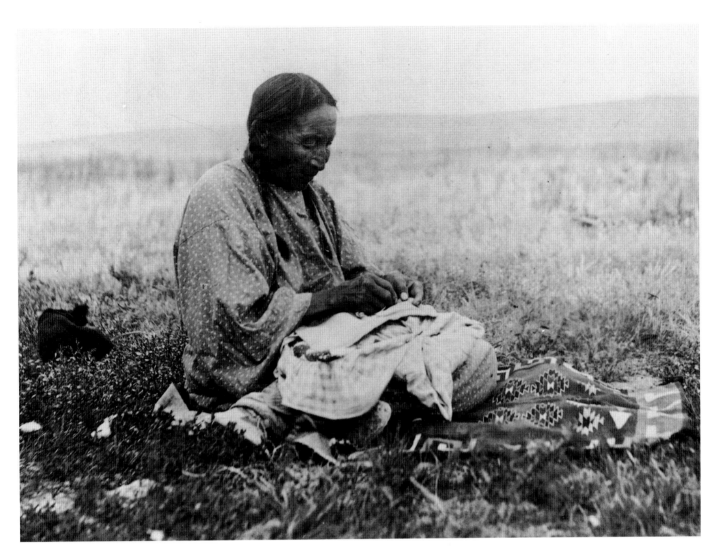

Brule Woman Decorating a Bag with Beadwork. Rosebud
Reservation. c. 1890. Courtesy the John Anderson Collection,
South Dakota State Historical Society, State Archives, Pierre,
South Dakota.

example of visual expression. The visual language of
Native American art is at once personal and cultural, and
it is the tension and resolution between these aspects
that often results in a true masterpiece. Today's society
concentrates on the creativity of the individual and
looses sight, perhaps, of the ways that personality is
shaped by cultural experience. The objects illustrated in
this book speak of the artist's distinctly cultural frame
of reference as well as how the artist reinterprets and
recreates the personal experience of culture in his or her
own work. It is the adept application of culturally
rooted visual language to unique and personal expression
that makes for a true "masterpiece."

This book covers the full range of Native American his-
tory, geography, and artistry. The colorplates are gener-
ally organized according to geographic region and cover
ancient through modern times. While is it somewhat
simplistic and something of an injustice to refer to the
hundreds of different indigenous North American cul-
tures collectively, this volume does attempt to seek out
a sense of unity that would justify bringing all these
objects together. Is there a unifying philosophy of visual
expression visible in these creations made by almost
countless generations of Native Americans? The answer
to the question requires much more than the simple
interpretation of culture-based visual signs. If such a uni-
fying philosophy exists, if a single voice does speak, it
must be sought in some underlying ideological founda-
tion that stems from the unique origins and long histori-
cal isolation of Native North American peoples. And
the only way such a foundation might be located is by
learning to "read" and understand the many different
images created by North America's separate and distinc-
tive indigenous cultures, thereby gaining insight into
the nature of the relationships between these people.

Art and Sacred Space

Anthropologist Evelyn Payne Hatcher has pointed out that European art often depicts the rendering of a moment from a certain point of view. The traditions of naturalistic representation freeze a moment of sensory experience and imply the moments before and after, thereby placing the experience in time. In contrast, Hatcher observed, Native American traditions of visual language often deal with an expression of space, a place through which time flows and yet remains constant. This space is not necessarily a geographic location, but a cosmos, the sacred environment which all things inhabit.

A sense of cosmos that transcends and encompasses transient experience pervades much of the symbolism of Native philosophy, ritual, and art. The earth, the land, is the central metaphor for this greater sense of cosmos, and it is perceived as a living, healing thing that participated in the Creation and will nurture life forever. Nowhere is this concept more clearly evident than in the monumental mounds and earthworks found throughout the Midwest and Southeast that were built by ancient Native Americans as part of healing and purification rites. In ancient midwestern communities, the bodies of the dead underwent a long period of care and preparation while family members reconciled themselves to life without a loved one and honored his or her memory with gifts and feasts. When the physical remains of human beings stayed too long on this earth, however, they posed a danger to those still living. Eventually, the remains of the dead were buried beneath a conical mound which, when covered with a mantle of earth, signified the return to the womb from which human life first emerged.

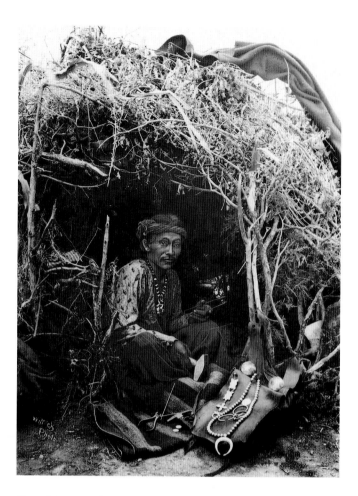

"JAKE." Navajo silversmith. Arizona. c. 1886. Courtesy the School for American Research Collections in the Museum of New Mexico, Santa Fe.

Evidence dates the beginnings of mound burial to the Late Archaic period, around 2000 B.C. Rituals of mound burial spread among several different regional cultures of the Woodland period (1000 B.C.–A.D. 900) and were followed by the erection of platform mounds by the more highly stratified societies of the Mississippian period (A.D. 900–1600). Platform mounds functioned as the foundations of temples, chiefly charnel houses, or chiefly residences. Periodically, these spiritually charged locations required cleansing and purification through the application of a fresh layer of healing earth. The same principles underly the Green Corn Ceremony of the Creek or Muskhogee people today, who are descendants of the Mississippians. On the occasion of the first harvest of green corn, the "square ground" or central court of the town center is cleansed by being covered with a fresh layer of purifying soil.

Native American ideology conceives of the earth as a large, terrestrial disk, its dimensions articulated by the four cardinal directions. Above and below the earth exist

parallel worlds, the one above separated from the world by the intervening sky, the other located below, beneath the earth's waters. Symbols of these cosmological principles underlie much of the nonrepresentational designs visible in, for example, the decoration of dress clothing of the Eastern Woodlands peoples. The equal-armed cross is a central metaphor for the earth's structure, each arm corresponding to one of the four cardinal directions. The shifting of color across symmetrical patterning or alternating color schemes in repeated motifs are rooted in the Upper World/Underworld dichotomy and are linked in a broader sense with the strong cultural value that seeks to reconcile polar opposites. The Upper World and Underworld are conceived as opposed to one another, existing in a state of perpetual conflict. The terrestrial earth situated between them reconciles their antithetical nature and exists ideally in a state of balance and harmony. This basic, ethical premise often informs principles of Native American design construction. The asymmetrical, serpentine floral pattern embroidered on one of an Ojibwa man's leggings, for example (see page 29), is restored to balance when worn with the symmetrically patterned other one of the pair.

Among many of the Woodlands and Plains peoples, gifts of power may come from spirit beings affiliated with one or the other of these sacred realms. When the young Gros Ventre holy man Bull Lodge lay with his back on the earth and prayed to the sky for a blessing, the thunder beings who lived there lowered a sacred war shield on a tether for his use. Objects or designs inspired by these experiences employ cosmological symbols to acknowledge their source. Bull Lodge's shield (see page 35) is painted with a pattern of three concentric circles, familiar Plains symbols emphasizing the unity of the cosmos, and a dot, which together add up to the number four signifying the four directions.

In the Southwest, the annual cycle of rainfall is crucial to the agricultural lifestyle of the Hopi and Zuni. Kachinas are the immortal beings whose appearance in the pueblos is linked to the annual occurrence of the rain that nourishes the land. For the Zuni, kachinas are some of the "raw people," ancient ancestors who still dwell in the world below the earth whom human beings left behind when they emerged into this world to live. The kachinas, who are impersonated by kachina dancers wearing masks, come annually to visit their "children." Kachinas are also identified with the clouds that appear during the rainy season so necessary for the successful cultivation of corn. The cycle of kachina dances binds the Zuni to the eternal cycle that causes the clouds of the Sky World to water the earth, and the water to well up from the earth as streams, springs, and lakes. Even the seemingly nonrepresentational designs painted on Zuni pottery are drawn from this deep and all-encompassing understanding of the way the universe works. On a Zuni jar (see page 57), a butterfly is perched on the stepped form of a thunderhead and framed by a hatched band also based on cloud forms. The design reasserts the simple but basic truth that all life stems from the cyclical movement of water.

The masquerades of the Northwest Coast winter villages are dramatic and elaborate rituals that also reconnect the temporal world of human experience with the timeless dimensions of the greater cosmos. The winter ceremonials of the Kwakiutl reenact encounters between mythic ancestors of powerful, highly ranked families and supernatural beings. Masks and props used for winter ceremonial performances bring these supernatural creatures into the present as a means of validating the family's claim to greatness. The Bella Coola *kusiut* society stage epic performances that present the most elemental of mythic beings, such as Ahlquntam, the Creator of the

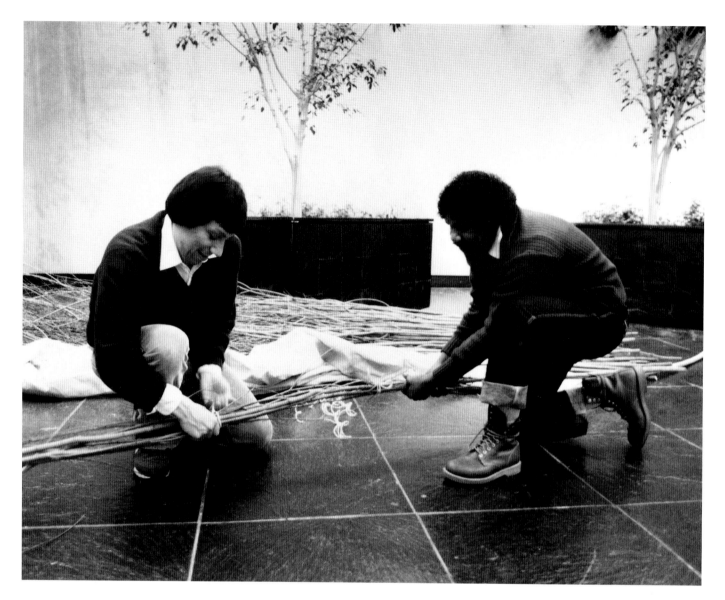

World, who rides the sun across the sky in his canoe and who causes the salmon to run in the streams every spring by reversing his great salmon skin cloak.

The arrival of the Europeans in North America early in the sixteenth century effected a profound change in the intended purpose behind the creation of Native American visual arts. Europeans and, later, European-Americans offered goods and cash for Indian curios, and many talented artists began to tailor their creations to satisfy the demand of outsiders. The impressive basket made by the Maidu artist Carrie Bethel (see page 85), or the skillful carving of a woman sculpted by an unknown

Haida artist (see page 99), display all the traditional skills that had been developed over many generations within the culture, but these pieces were produced for a market outside the community. It was at this point that the history of Native American art began to merge with the art history of the larger world.

Native American artists have always welcomed the opportunity to work with new media. During the first decades of the twentieth century, an increasing number of Indian artists began to employ the traditional fine arts media of watercolor on paper or oil on canvas. The earliest twentieth-century Native American painters were often self taught and worked in a direct style of pictorial narrative, as if to explain, with pictures, what it was to be Indian. Ernest Spybuck's watercolors document the panoply of Shawnee ceremonies with details that only an eyewitness could recreate. Spybuck never glamorized or romanticized Indian life: he wanted simply to show the

events of Shawnee social and religious life clearly while conveying a sense of the excitement, energy, and good fun. Maidu painter Frank Day also spent his life creating pictorial interpretations of his people's cultural history, but he presented depictions of Maidu mythology based on the stories of elders. Day's pictures are pedagogical in purpose: his solidly painted figures enact their mythic narratives in a manner calculated to instruct. Anthropologists were attracted by both Spybuck's and Day's expository methods, and both artists were eagerly commissioned to produce ethnographic illustrations.

More recent generations of artists of Native American ancestry have become students of the modern objectives of contemporary art. Some have tried to follow modern art practice by imbuing their work with personal expression while at the same time trying to preserve their distinctly Native American content. Santa Clara Pueblo potter Roxanne Swentzell, for example, has combined her traditional instruction with a more personal and contemporary vision. Swentzell expanded on the work of earlier Pueblo potters who experimented with figural forms for the curio market, but added her contemporary sense of invention and playfulness. Her animated figures, although molded with a potter's hand, are better understood as sculpture.

It is a fact of Native American history that not all Indian people of recent years have been raised in traditional communities that have preserved craft traditions. Many Indian people of today see themselves as firmly within the mainstream of the modern world. Recent generations of artists assert that an "American Indian" cultural experience of the late twentieth century defies any generalization; rather, it is their own experience as people of Indian ancestry, no matter where they were raised or what their background, which gives their art meaning. American Indian art, then, becomes as diverse as the lives and personalities of the artists themselves.

Many contemporary artists, in their search to find what is uniquely "Indian" in themselves, sometimes encounter age-old themes. Cherokee artist Kay WalkingStick has attempted to summarize in her paintings the ancient concept of polar opposites: the difference between Eurocentric and traditional Native North American objectives of representation, between time and place, (time without place—place without time), between the temporal and the spiritual. Her paintings are diptychs, two separate images side-by-side, each intended to represent different aspects of the same thing. One side is always an image of a landscape, often including mountains or streams, painted broadly so that the movement of the paint when applied to the panel evokes the movement of water across stones or the sculpting action of time and erosion against the face of a boulder. The temporal world of action is represented in sensorially inspired images and the mimetic tracings of paint that actually created the image.

The other side of the diptych represents WalkingStick's attempt to render place without time, the world known through spiritual rather than sensory knowledge. This surface is a heavily worked encaustic of layered color with a texture void of any trace of the hand or movement. A geometric shape, relating in some instances to ancient symbols of the four cardinal directions, hovers within a timeless environment. This side is not an abstraction of the other, but an equivalent based upon another way of knowing. WalkingStick's attempt to find a pictorial means of representing the nature of the world as it is known through the soul rather than only through the

eyes recalls the objectives of many previous generations of Native American artists. This spiritual regard for the earth and the temporal environment as part of something greater than the self is visible throughout much of Native American art.

Art and "Indian" Identity

Native American artists today struggle to preserve cultural diversity within the larger Native North American community while at the same time maintaining a sense of unity among all Indian peoples. It can be argued that "Indianness" is a Eurocentric concept stemming from the colonial view that all Native North American peoples, regardless of their ethnic identity, were essentially the same. Certainly, a sense of unity stems from the collective experience of a colonial history wherein all Native people were treated with the same sense of patronizing disregard and were subjected to similar acts of brutalizing subordination.

The invention of the "Indian" as a stereotyped cultural construct can be credited to the conquerers and colonizers of North America. During the age of Columbus, "India" simply meant the unknown lands beyond the known Orient (the Middle East of that time), and "Indians" were its exotic inhabitants. Exactly how to define these "Indians" is an issue that has been contested and negotiated between Native peoples and outsiders ever since. The visual arts have been fertile ground for this identity struggle as artists try to reconcile through their work the strong voice of traditions, the realities of modern life, and the Indian fantasies promoted by popular culture. George Longfish, in his monumental painting

featured in this volume (see pages 106–107), unexpectedly claims the Teenage Mutant Ninja Turtles as updated, late twentieth-century Mohawk warriors of the Turtle clan. These are the kinds of visions that keep familiar stereotypes at bay.

Many contemporary Native artists, writers, and thinkers have addressed the issue of a unifying philosophical tradition, whether such a thing exists, whether there is something spiritual, moral, or ethical that binds Native people together. Cree artist Alfred Young Man has posited the existence of the "Native perspective." George Sioui Wendayete coined the term "Americity" to describe a distinctly Native North American morality and spirituality distinctly separate from European belief systems. Jaune Quick-to-See Smith has said, "We have a horizontal sense of time which compresses history and present reality." And Kay WalkingStick stated simply and eloquently, "The key is that the earth is sacred. Those of use who are Native American talk about it."

The unifying elements of a more broadly defined Native American identity are not exclusively racial, but also culturally based, meaning that cultural teaching and experiences shape a perception of reality. Unlike the philosophical traditions of Europe, which have been documented in generations of literary texts, the core teachings of Native American culture derive from oral and visual traditions, the communication of life wisdom between and across generations. In fact, the only permanent and material record of a Native American philosophy of art is the work itself, objects like those illustrated in this book. If there is a unifying spirit that unites these diverse works, it may be beyond words to tell.

Native American Art
M A S T E R P I E C E S

Effigy of a Human Hand

Ohio Hopewell

Middle Woodland period, 200 B.C.–A.D. 400

Between approximately 200 B.C. and A.D. 400, an era known as the Middle Woodland period, the peoples of the Eastern Woodlands region developed a seminal tradition Native American art. Middle Woodland cultures were the first in North America to leave a durable record of their spiritual life in their works of art, handworks that represent the earliest preserved expression of a Native American visual language employed to convey ideas about the sacred. Images of animals, spirit beings, and ancestors recovered from Middle Woodland period archaeological sites all testify to spiritual concepts that would provide a foundation for the centuries of religious practice and belief that were to follow.

This episode of North American art history is often referred to as "Hopewell," named for the Hopewell burial mound site near the Scioto River in Ohio. Although the Hopewell site was one of the largest and most elaborate of the Middle Woodland period mortuary sites, the Hopewell phenomena included many additional regional traditions and sites found from the eastern seaboard to the Missouri valley, from the Great Lakes to the Gulf of Mexico. These locations were home to preagricultural people adept at harvesting the abundant natural resources of the environment. They lived in riverside villages in modest homes made of ephemeral wood and bark. The regionally disparate cultures of the Middle Woodland period established far-flung networks of exchange which trafficked in exotic materials such as obsidian, marine shell, copper, and grizzly bear teeth. Trade networks circulated not only materials, but also the ideas and ideologies which inspired the creation of artistically fashioned and symbolic objects. These treasured pieces, made with Hopewell exotic materials charged with powerful symbolism, were often buried with the dead beneath conically shaped mounds of earth.

This elegant silhouette of a human hand made from translucent, muscovite mica accompanied the burial of two men laid side by side beneath Mound 25 of the Hopewell site. In addition, both men were draped with strands of shell beads and river pearls. Copper axes, chipped flint blades, and bone awls were placed close by. The Ohio Hopewell recognized translucent mica as a spiritually potent substance. Later American Indian cultures recognized the translucent qualities of mica as a symbol of spiritual purity. Ohio Hopewell sometimes carpeted the floors of their burial mounds with irregularly cut sheets of mica prior to construction of the mound. Covering the remains of the dead with a mantle of mica was probably performed as a ritual of purification intended to separate, once and for all, the remains of the dead from the society of the living.

This singular object combines the purifying significance of mica with the effigy of a human hand. The elegant shape, with its elongated, graceful fingers, represented the preserved hand of a honored ancestor. Hopewell cultures sometimes retained the relics of important community members, such as their hands or skulls, and considered them sacred. The small holes perforated through the palm of the hand suggest that the mica object was worn as some kind of ornament, perhaps across the breast of its owner, prior to interment. The combined symbols of ancestral relic and spiritually purifying mica communicated the powerful identity of the person who wore it in life and took it as a burial offering in death.

Hopewell site, Ross County, Ohio.
Muscovite mica.
Length: 11 1/2 in.
Ohio Historical Society, Columbus.

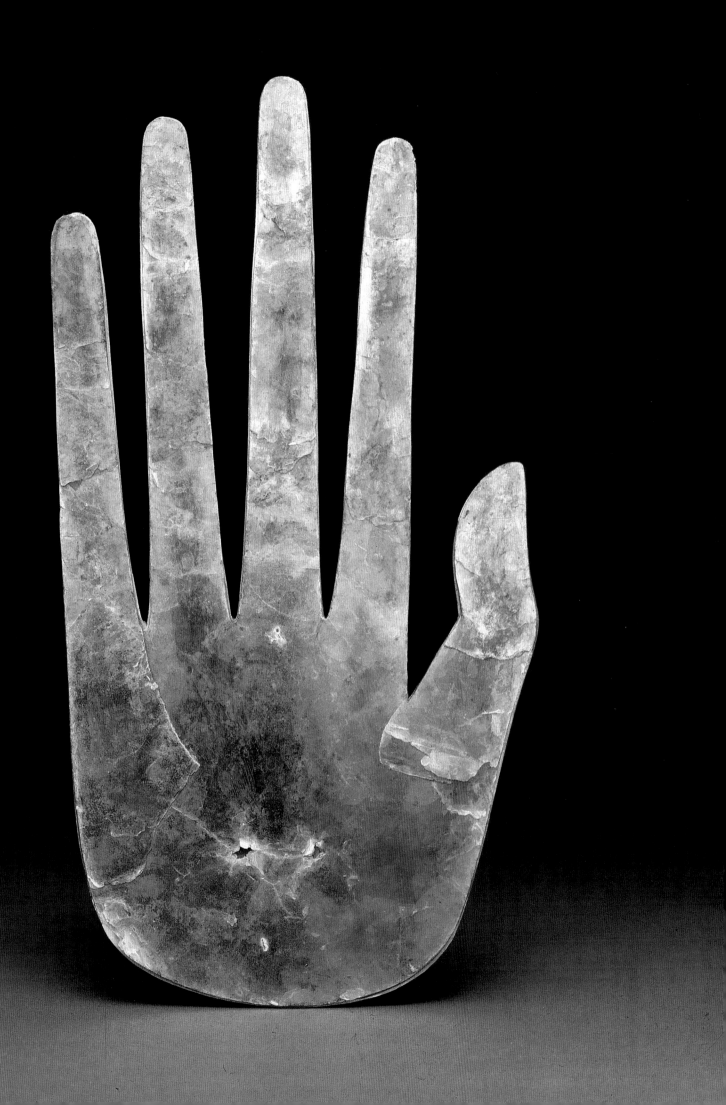

Mask with Antlers

Caddoan culture (Spiro phase)

Mississippian period, A.D. 1200–1350

The Mississippian period of North American prehistory is characterized in the Southeast as a historically significant episode of political organization and city-building. The city of Cahokia, for example, located in the Mississippi bottom lands near present-day St. Louis, numbered at least 20,000 in A.D. 1100.

The ancient Caddos, residents of the rolling woodlands and prairies of western Oklahoma and eastern Texas well to the south of Cahokia, were not a typical Mississippian society. They did not build large cities or platform mounds as did their neighbors, although they probably often visited those settlements as traders. Caddo towns and villages were more modest in size and spread out over a broad expanse of landscape. Although their communities departed from characteristic Mississippian centralization, the Caddos did share much of their ideology and visual symbolism with other Mississippians, as is testified by their archaeologically recovered art.

During the period between A.D. 1200 and approximately 1400, the Spiro site was the spiritual center for the Caddo. Here is where the chiefs and priests from high ranking families found a final resting place after death. Their bodies were brought to the site with abundant offerings of sacred objects—wooden carvings, engraved shell cups, shell ornaments, stone smoking pipes, ear ornaments, and other items of regalia—that were collected from Caddoan temples and arranged in a large ossuary pit. A great, irregularly shaped mound of earth that was piled over the ossuary is known today as the Craig Mound. Although the Craig Mound was looted of its contents for profit during the 1930s, it is evident from those objects that have been legitimately removed that it once contained the most extensive collection of burial offerings ever assembled for a mortuary ritual in indigenous North America.

This nearly life-size "mask" with antlers made of wood and eyes and mouth inlaid with marine shell came from the "great offering," as the ossuary is called, within the Craig Mound. Several wooden objects survived in the mound due to their proximity to the large number of copper objects whose salts helped preserve the wood from decay. This mask and other small wooden heads also recovered from the mound may have functioned as effigies of human relics, the preserved heads of sacred ancestors whose remains had been cared for in temples for many years prior to interment in the Craig Mound. As was customary practice during the Mississippian period, the preserved relics of the elite dead, along with other sacred objects that were kept in temples, were periodically cleaned out and buried as a rite of purification and closure.

Mississippian temples customarily contained both the preserved relics of more recently deceased ancestors and effigy representations of ancient and mythic forbears. This head represents one such mythic being, its "antlers" or horns conveying the message that this individual possessed sacred power. The gleaming shell for the eyes probably also carried symbolic, spiritual meaning, since historic descendants of Mississippians regarded shell as a sacred substance due to its white color and rich luster. This particular mask was the largest and most elaborately constructed of the wooden heads that were recovered from the Craig Mound; it no doubt embodied a powerful culture hero.

Craig Mound, Spiro site, Leflore County, Oklahoma.
Wood (possibly cedar).
Height: 11 ½ in.
National Museum of the American Indian, Smithsonian Institution, New York.

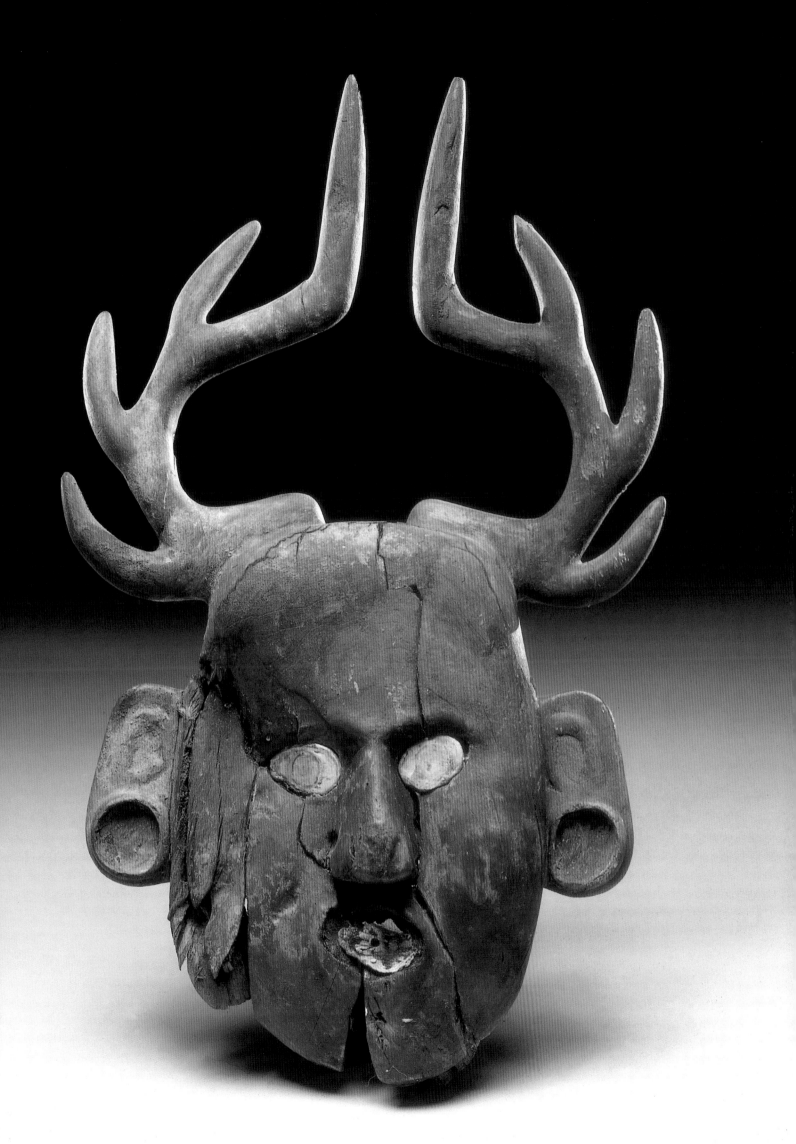

Kneeling Cat Effigy

Calusa culture

Late Mississippian or early historic period, A.D. 1400–1600

The Calusa of the sixteenth century were a powerful chiefdom of some fifty villages in southern Florida led by the centralized authority of a chief and his family. Unlike the neighboring cultures to the north, the Calusa did not have to depend primarily on corn agriculture since the waters of the southern Florida coast provided abundant food. The Calusa built villages on artificially constructed mounds along the coastal lowlands. Archaeologists have found the mounds filled with the shells of edible mollusks, the debris of many generations of habitation.

The Calusa were a sea-faring people. When Ponce de Léon's 1513 expedition first arrived in southern Florida it was greeted by a flotilla of over eighty canoes of hostile Calusa warriors. Ponce de Léon later died of a Calusa arrow when he returned to the territory in 1521 to build a settlement. Pedro Menendez de Aviles, who in 1565 was chartered with establishing and administrating Spanish settlements in Florida, married the sister of the Calusa chief Carlos in a ceremony calculated to seal the alliance. The union may well have been initiated by the Calusa, since marriage of the chief's sisters and daughters to foreign leaders was the customary way they employed to expand their dominion over neighboring cultures. Over the following century, Calusa seafarers preyed on European shipping off the coast and traded directly with Havana, traversing the open water of the Caribbean Sea in ocean-going canoes. Their numbers diminished, however, due to disease, internal dissension, and conflicts with their neighbors and the Spanish. The Calusa had left the mainland and moved to the Florida Keys by the mid-eighteenth century. When the Spanish ceded Florida to England in 1763, most of the remaining Calusa moved to Havana.

Key Marco is one of the best known Calusa archaeological sites because of the wealth of wooden objects that were found preserved in its oxygen depleted muck. Frank Hamilton Cushing, one of America's first anthropologists, excavated the site in 1895. Although the excavation techniques were not sophisticated enough to determine the type of structures that had been built at the site, the large number of ceremonial objects Cushing's excavation recovered pointed to the probable existence of a temple. Among the contents of the site were a set of painted wooden face masks and several startlingly beautiful sculptures of animal heads.

With its long, graceful body and inscrutable expression, this diminutive, kneeling figure with a feline face is one of the most elegantly carved objects from the temple. Representations of spirit beings in Native American art often combine human and animal attributes. The intent is not to represent the physical appearance of the spirit being, but, rather, its inner identity. This creature is undoubtedly linked to the cougar, one of the most intelligent, powerful, and dangerous creatures of the Florida mangrove swamps. Very likely, it was installed in the Calusa temple at Key Marco as an effigy of a spirit being from whom the community sought blessings.

Key Marco site, Collier County, Florida.
Wood.
Height: 6 in.
National Museum of Natural History, Smithsonian Institution,
 Washington, D.C.

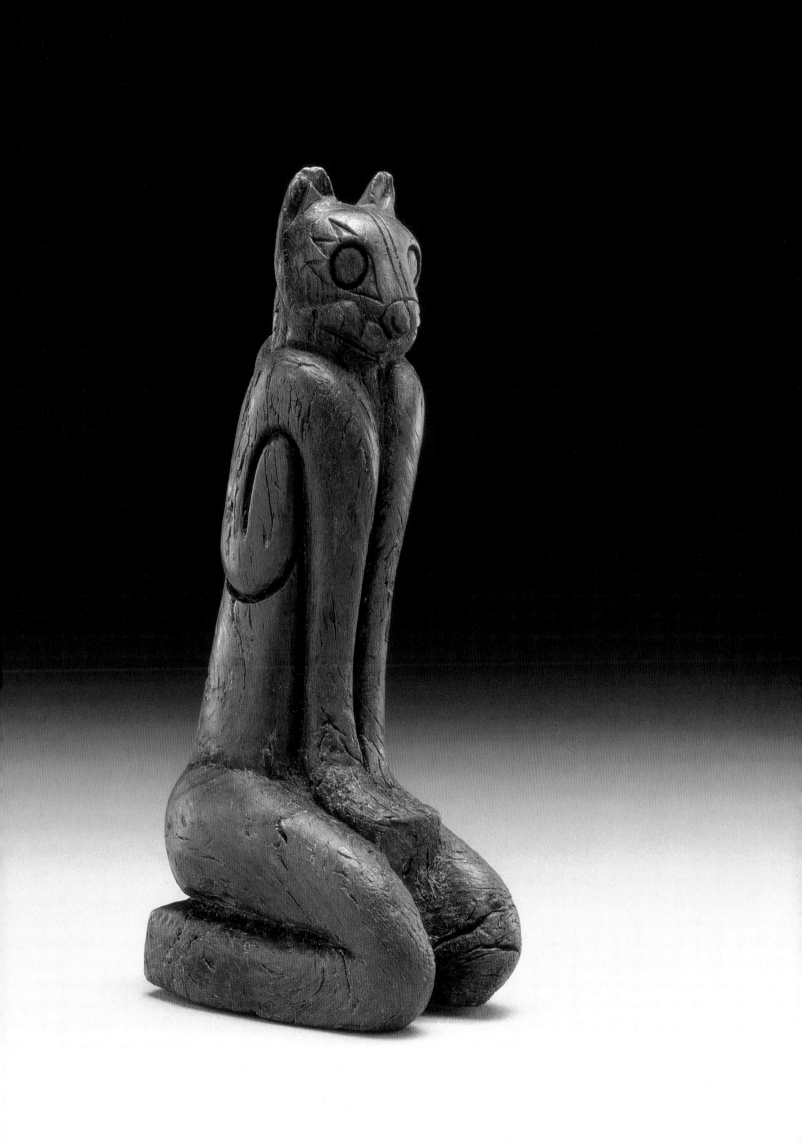

Hunting Coat

Delaware or Shawnee

Early 19th century

While many British colonists clung to the Atlantic coast during the eighteenth century, some joined other enterprising Europeans who penetrated the southeastern interior seeking Native partners for the lucrative trade in animal hides. While the pelts of beaver dominated the French fur trade in the northern Great Lakes region, the southeastern English traded with the Creek and Cherokee for the supple hides of white tail deer. Although primarily an agricultural people, many Creek and Cherokee families grew wealthy and influential as skilled hunters for the trade. Family heads and town chiefs prospered, acting as intermediaries for European traders. Wealth, however, had little meaning as "capital" to these Native peoples. Its value lay, as it had for generations, in providing the wealthy with the ability to distribute gifts, sponsor feasts and ceremonies, and transform material wealth into visual symbols of success and spiritual well-being.

For American Indian men of the Southeast engaged in the fur trade, the hunting coat was a garment that represented prestige and accomplishment. The fitted waist, flaring skirt, tailored sleeves with cuffs, and the short cape, or tippet, which hung from the shoulders were all attributes adapted from European-style garments, but Indians cut the pattern in finely tanned deerskin. The embroidered decoration was accomplished with small and colorful glass beads stitched to the garment. A man acquired the deerskins through hunting; a woman tanned the hides and applied the decoration. The beads were procured from a trader in exchange for furs and hides and thereby represented fur trade wealth and successful entrepreneurship.

Although the hunting coat, with its heavily fringed tippet, was most popular among the Cherokee of Georgia, the glass bead embroidery on this coat suggests it was probably made by the Delaware or Shawnee of Indiana. The Delaware lived in the region of Chesapeake Bay at the time of European discovery. They moved inland to the interior of what is now New Jersey and Pennsylvania during the seventeenth century to avoid the coastal colonies. By the eighteenth century, they resided in southern Ohio and Indiana just to the northwest of Cherokee territory in northern Georgia and eastern Tennessee. The Shawnee, also of Ohio, are related to the Delaware linguistically and had a long history of relations with the southeastern Creek and Cherokee peoples.

The fashion for the popular style of southern hunting coat spread among these southern Algonquian-speaking peoples during the early decades of the nineteenth century. The bright, "hot" colors and abstract floral designs visible on this coat were new and innovative for the time. The four-petaled flowers in red, however, derive from the ancient, pre-European symbol of the equal-armed cross, which signified the four cardinal directions and thereby the dimensions of the terrestrial earth. Nineteenth-century Eastern Woodlands women artists developed many innovative techniques and styles of ornament for the fabrication of regalia, or dress clothing, but underlying all the great experimentation and change were ancient principles of design established by revered ancestors.

Indiana or Ohio, southern Great Lakes region.
Deerskin, silk ribbon, glass beads.
Length: 39 ½ in.
The Detroit Institute of Arts.

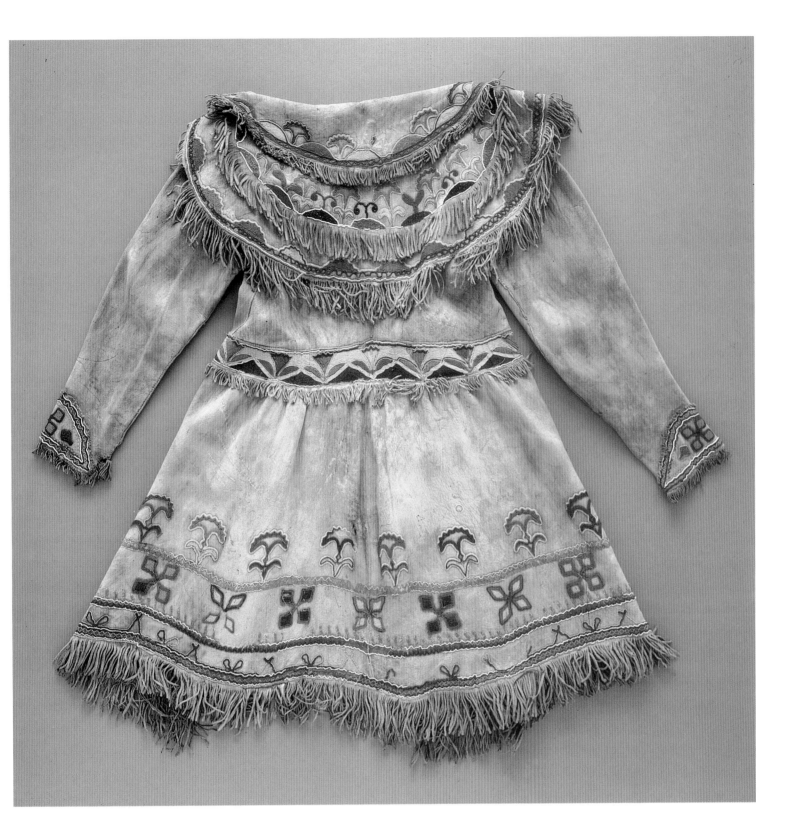

Ball-Head Club

Iroquois

19th century

Defense was one of the primary responsibilities of men in Native American communities. Those men who acted selflessly to defend their homes and families were highly honored. The warrior tradition still exists today in Indian communities where there are many veterans who served in World War II, Korea, Vietnam, and the Persian Gulf. Combat entails risk and danger. Since Native tradition holds that success and safety depend on spiritual sanction, warfare is regarded as a sacred endeavor, not to be entered into lightly, and only by those who are spiritually prepared. In traditional warfare, use of a hand weapon proved special bravery. The Iroquois ball-head club, or *gajawa*, was made with spiritual blessings and was thought to possess special power that made the club even more potent as a weapon and as a protective object for its owner. Warriors who owned such weapons would not permit women, children, or strangers to touch them for fear that they might endanger themselves.

The Iroquois possess a long warrior tradition. Ever since the confederacy of Mohawk, Oneida, Onondaga, Cayuga, and Seneca banded together for mutual defense, perhaps as early as the fourteenth century, the Iroquois have been a formidable military presence in the Northeast. Within the delicate politics of relations between colonial powers and Indian trade partners in seventeenth- and eighteenth-century North America, the Iroquois played a decisive role. The threat of Iroquois mobilization maintained a balance of power between French and English while allowing the Iroquois a lucrative middleman position in the fur trade. Seventeenth-century Iroquois launched raids against French trade partners as far west as Illinois that were intended to intimidate rival tribes and control access to trade goods. Iroquois warriors also fought in the French and Indian War and in the American Revolution.

This club was fashioned from the curved root of a tree, the grain of the wood following the curve of the club, insuring strength. The striking end of the club was carved with the form of a monstrous creature who holds a ball in its mouth. The warrior who wields the club emulates the aggressive act of the predator who lunges at its prey with its jaws. The monstrous creature is linked to the potent powers of the Underworld, a watery, subterranean realm beneath lakes and rivers inhabited by horned serpents and other supernatural beasts. Engraved on the lower portion of the club's handle is the image of a turtle. This symbol very likely represents the clan membership of the club's owners. Iroquois social organization includes several clans, a grouping of one or more families who consider themselves kin. The clans are named after animals: wolf, bear, hawk, deer, and turtle prominent among them. Iroquois men used images of their clan animals as signatures on documents, in pictographic histories of events, and on objects such as this club.

New York State.
Wood.
Length: 19 3/4 in.
Cranbrook Institute of Science, Bloomfield Hills, Michigan.

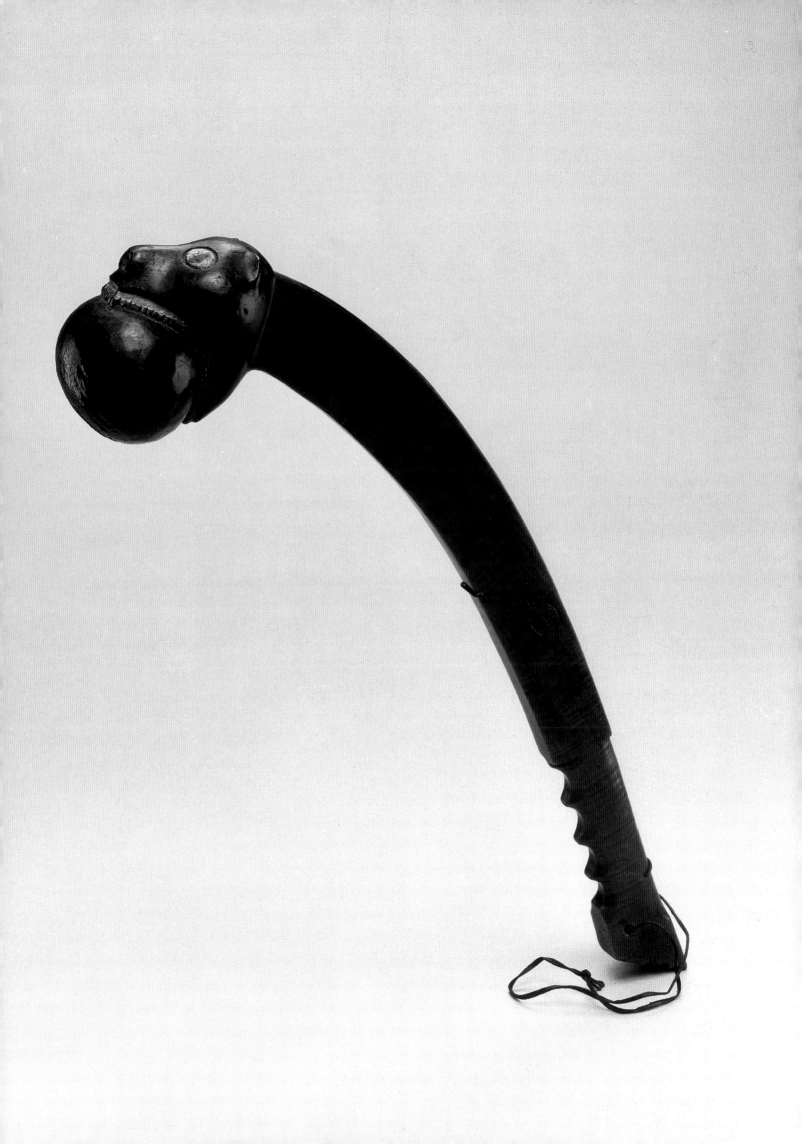

Man's Leggings

Ojibwa

c. 1900

Dress clothing and the occasions such as social dances and religious ceremonies during which it was worn became an important means of preserving a sense of cultural identity after the onset of the "reservation period" late in the nineteenth century. The Indian Removal Act signed into law by Andrew Jackson in 1830 forced tens of thousands of Eastern Woodlands people to leave their traditional homelands in the east and resettle in "Indian Territory" reservations, mostly in Oklahoma and Kansas. Those who lived in more remote areas to the north were spared removal, but logging interests and more aggressive European-American settlement forced land sales that encroached on the land originally allotted to reservations. Indian children were forced to attend school where speaking their native language was forbidden, and they were taught that the old culture was obsolete in the modern world. Traditional livelihoods collapsed, and poverty, often starvation, resulted. Fortunately, dress clothing, regalia, and the occasions to wear it continued to celebrate traditional Native values. Throughout the late nineteenth century, the traditions of women's craft work that were carefully passed from one generation to the next played a large part in the survival of Indian culture.

Ojibwa women of the White Earth and Red Lake reservations in Minnesota excelled in glass bead embroidery executed in a naturalistic floral style, like that visible on this particularly beautiful and meticulously decorated pair of man's leggings. Subtle colors represent abundant varieties of leaves and blossoms that are arranged on gently meandering stems. The heavy, dark blue velveteen provided a sturdy support for the weighty beads. The patterns were embroidered on these dance leggings, which were part of a man's formal regalia worn during social dances and religious ceremonies. The leggings were pulled up each leg and tied at the hip to a belt. They were worn with a breechcloth or apron, also elaborately beaded, along with a colorful, printed cotton shirt decorated with silk ribbon. Beaded moccasins, garters tied around the leggings just below the knees, woven sashes worn across the shoulders, and other decorative accessories completed the dance outfit.

Ojibwa women of Minnesota originally learned the floral style from missionary teachers who had taught them to use silk thread to embroider tablecloths and napkins. The students however, adapted the designs using glass beads to enhance their own tradition of decorating regalia. In this way, the women appropriated the designs and made them part of their own sense of tradition.

Minnesota.
Cotton velveteen, polished cotton, glass beads, wool twill.
Length: 29 3/8 in.
The Detroit Institute of Arts.

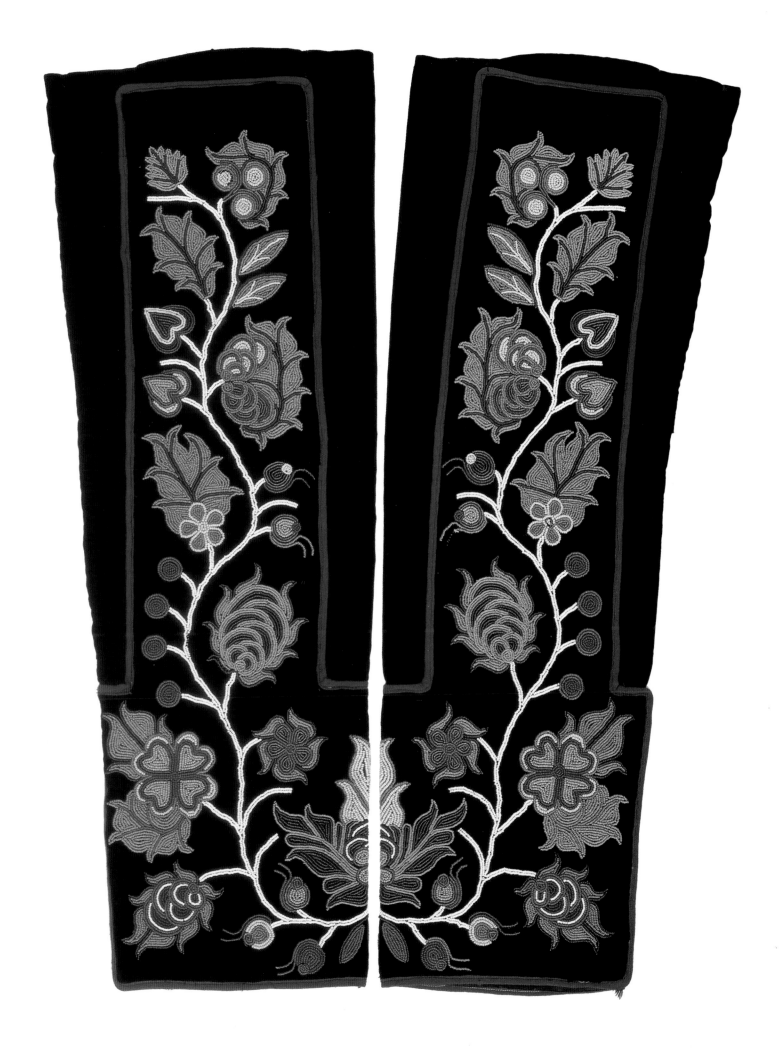

Picture of Chicken Dance

Ernest Spybuck (Shawnee, Oklahoma)

Early 20th century

The so-called Absentee Shawnee left their homeland in Ohio during the American Revolution in order to avoid becoming embroiled in the conflict. They crossed the Mississippi and never looked back. Throughout the early part of the nineteenth century they drifted to locations ranging from Missouri to Texas, until, in 1872, they were granted title to land in the territory of Oklahoma adjacent to the Potawatomi. The Absentee Shawnee remained the most conservative of the three Shawnee bands, preserving many of the traditional Shawnee rituals on their Oklahoma reservation.

Ernest Spybuck was born in this community in 1883 and rarely left his birthplace. One of his teachers at the Shawnee Boarding School recorded that Spybuck was always drawing and painting as a child. He made pictures that carefully illustrated his experiences, but he never embellished them with fanciful detail. He painted with a pictorial directness that stemmed from the fact that he was completely self taught as an artist. The anthropologist M.R. Harrington so admired Spybuck's abilities that during the 1910s and 1920s he commissioned him to execute a series of twenty-four paintings depicting Shawnee ceremonies. Since then, Spybuck's pictures have been used frequently as ethnographic illustrations.

In this engaging picture, Spybuck illustrates what M.R. Harrington called a "chicken dance." The dance ground is situated within a grove of trees with shady arbors of leafy branches supported by a scaffolding of poles behind and to the left of the dancers. The participants arrived in covered wagons, visible in the background, and have set up a camp of tents for a celebration that will last several days. The chicken dance is just one of a variety of social dances performed by the Shawnee, each with its own songs and distinctive structure and movements.

This kind of event anticipates the modern powwow enjoyed by Indian people today all over the United States. Women are dancing heel-to-toe and counter-clockwise around the singers, who drum in the center. The drummers wear brimmed hats with eagle feathers. Their cotton shirts are trimmed at the cuffs and breast with narrow bands of silk ribbon. The dancers are dressed in fine shawls, some decorated with silver brooches and others made of store-bought plaid wool, which became very popular during the early twentieth century. Some hold fans or have massive necklaces of glass beads draped around their necks. The dancer farthest to the right is elegantly clad in a red cotton blouse decorated with silver brooches, and her beautiful long tress of hair is wrapped with silk ribbon pendants descending down her back nearly to her feet. Men seated in the foreground watch the dancing. Soon each woman will choose a man with whom to perform the next part of the dance.

Spybuck emphasizes the individuality of each participant by the variety of clothing styles, the assorted postures, and distinctive facial expressions. He injects no sentimental romanticism in his depictions of Shawnee life, just the warm and knowing observation that comes from an insider's view. His faithful rendering of ritual detail and regalia is in no way burdened by solemnity. Rather, Spybuck's paintings convey the sense that these were joyful, celebratory occasions when people assembled to have a good time.

National Museum of the American Indian, Smithsonian Institution, New York, collected by M.R. Harrington.

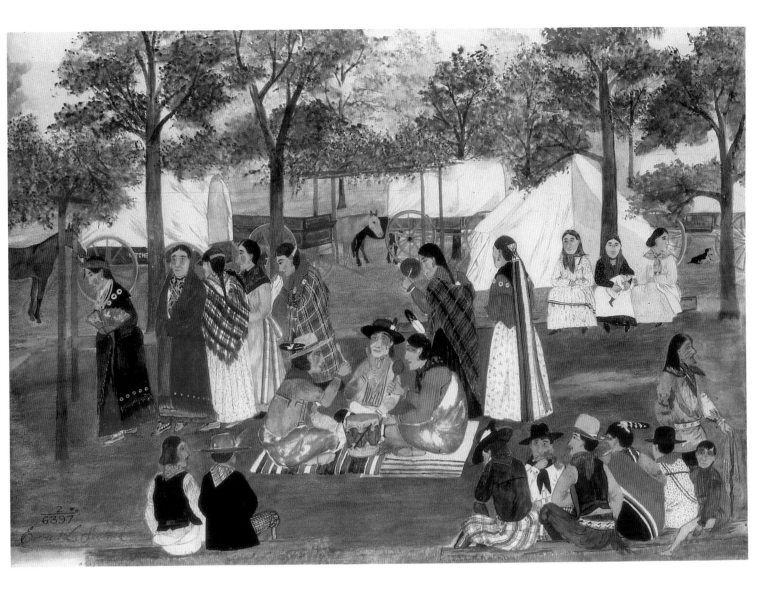

Square Hand Drum

Assiniboine or Yanktonai

c. 1860

Traditional men of the Plains tribes believed that the accomplishing of great things required support and blessings from the spirit world. From a young age ambitious men sought visions in which spirit beings offered gifts of spirit power and instruction in sacred knowledge. A man embarked on a vision quest by fasting for at least four days (the number four is considered sacred) in a remote spot, often a mountain top or a secluded ledge overlooking a ravine. Fervent prayer, offerings of tobacco, and sometimes self-inflicted suffering were thought to bring visions during dreams.

During the vision, a spirit being in the form of a person or an animal would approach the young man and direct him in one of several ways: he might receive instruction about the powers of a certain kind of ritual, or perhaps a warning against performing certain acts, or receive as a gift a particular design that might be painted on his body, horse, or shield. Blessings from the spirit world gave men strength to elude harm in battle, skill to hunt successfully, or knowledge to heal the sick. Only certain men experienced visions; often the most determined seeker of power saw none, while a few men might experience many. Holy men were often those who had been selected by spirit beings, having been "called" through spontaneous dreams and visitations.

Among the Sioux, disease was understood traditionally as a spiritual rather than a physical or medical problem. It was caused by mysterious power that had a potential for harm or benefit, depending on the circumstances of one's encounter with it and one's spiritual preparedness. Holy men, who possessed great skill in dealing with matters of sacred power, were often able to cure disease. They healed the sick by singing prayers accompanied by rattles and a drum, such as this one, which was held in the hand and played with a stick. The sounds of these instruments pleased the mysterious powers that had caused the illness.

This hand drum once belonged to a Sioux holy man, perhaps a member of the Yanktonai band, who were settled at the Fort Peck Reservation in eastern Montana, where the drum was collected during the 1880s. Like many others of its kind, the drum is painted with the image of a spirit being, the source of the holy man's power. The design was inspired by a visionary experience, a dream in which this creature appeared to the dreamer. The mysterious being is crowned with two horns, elements that are often seen on Sioux ceremonial objects and dress. Its face is impassive and remote, animated only by the two eyes glowing red. Its black wings are striped with wavering bolts of lightning in opposing yellow and red, while two balls of spiritual energy, red and green, hover above its head. The square shape of the drum is unusual since most drums are circular, but the famous Hunkpapa warrior chief Sitting Bull did own a similar square shaped drum. In terms of dramatic force and mysterious presence, this is one of the most powerful examples of traditional visionary painting produced by any of the Plains tribes.

Fort Peck Reservation, eastern Montana.
Deerskin, wood, pigment.
Length: 15 1/4 in.; width: 16 1/2 in.
Collection of Richard and Marion Pohrt.

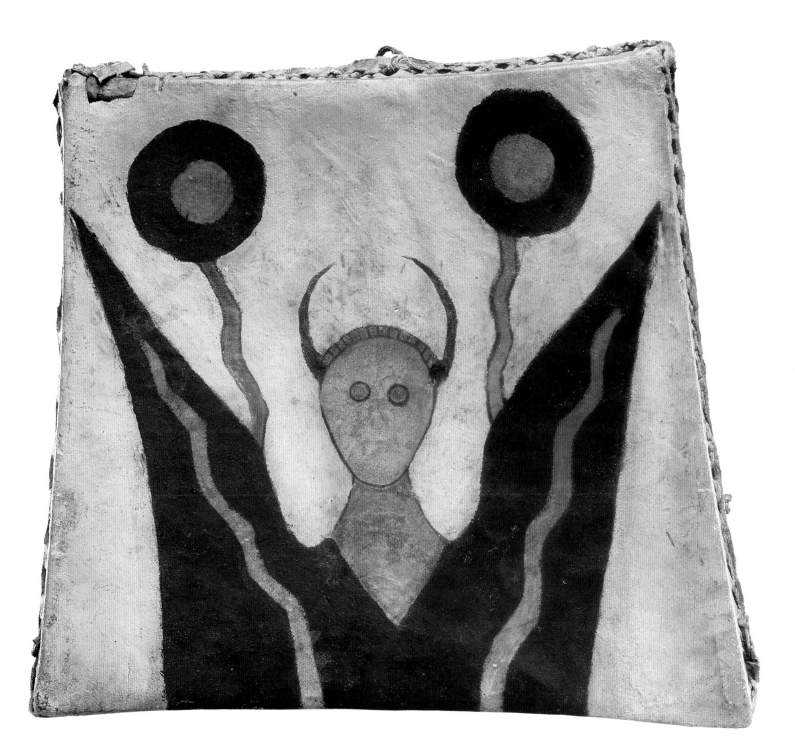

Bull Lodge's War Shield

Gros Ventre

c. 1850

The Gros Ventre are a small Plains tribe that have never numbered more than three thousand people. They have lived on the northern Plains for as long as history or oral tradition has been recorded, having been one of several tribes who acquired knowledge of horses during the early 1700s. Records kept by traders trace the movement of the Gros Ventre across the plains of Canada during the eighteenth century. By the nineteenth century, they had established themselves north of the Missouri River in present-day Montana, a location that still includes their current home at the Fort Belknap Reservation.

One of the most famous of the Gros Ventre leaders was a warrior and holy man named Bull Lodge. He served as a keeper of the Feather Pipe, one of two sacred pipe bundles that had been given to the Gros Ventre by the Creator. The Feather Pipe and the Flat Pipe had a temporary "keeper," a holy man who cared for it and performed its ceremonies for the welfare of the people until it was time to pass the bundle along to a member of the next generation. The role of pipe keeper was a weighty and highly honored responsibility.

The Thunder Beings, spirit beings of the Sky World, had selected Bull Lodge to be the keeper of the Feather Pipe, and had bestowed powerful blessings upon him. Bull Lodge was known throughout the Plains for the strength of his thunder power, his exploits recorded with respect even in the war stories of his enemies. Once, Bull Lodge and his war party were trapped in the brush of a river bottom by enemy warriors of the Crow tribe. The Crow set the brush ablaze to drive out Bull Lodge's party. To save himself, Bull Lodge sang to the Thunder Beings, who brought rain to put out the fire, and he and his party escaped. The Crow men who were present talked of this for years after.

Bull Lodge's powers stemmed from seven visions experienced during his lifetime. The first came to him when he was a young man. One day, after his camp had moved on, Bull Lodge stayed behind at the campsite and lay on the ground, staring at the sky and praying for a vision. He saw a circling bird, which came lower and lower, until he saw that it was a war shield encircled with eagle feathers being lowered to the earth on a tether that stretched up into the sky. The shield came lower and lower until it rested on his chest. Then he heard a voice that said, "My son, look at this thing. I am giving it to you from above. I command you to make one just like it." The shield then rose up into the sky.

The shield is cut from a double thickness of buffalo rawhide glued together. Eagle feathers adorn the edges in honor of Bull Lodge's spirit protector, the Thunderer. Small bundles of tobacco attached to the shield were intended as offerings. Three red concentric circles and a dot in the center add up to the number four, the sacred number of the cardinal directions. Long lost is a deerskin cover that was attached over the front with a draw string and painted with the image of a Thunderbird. Bull Lodge's shield is the only Gros Ventre war shield that has survived to the present day, sad testament to how much Gros Ventre art has been lost.

Montana.
Rawhide, deerskin, wool cloth, eagle feathers, brass hawk bells,
 glass beads, porcupine quills.
Diameter: 21 in.
Collection of Richard and Marion Pohrt.

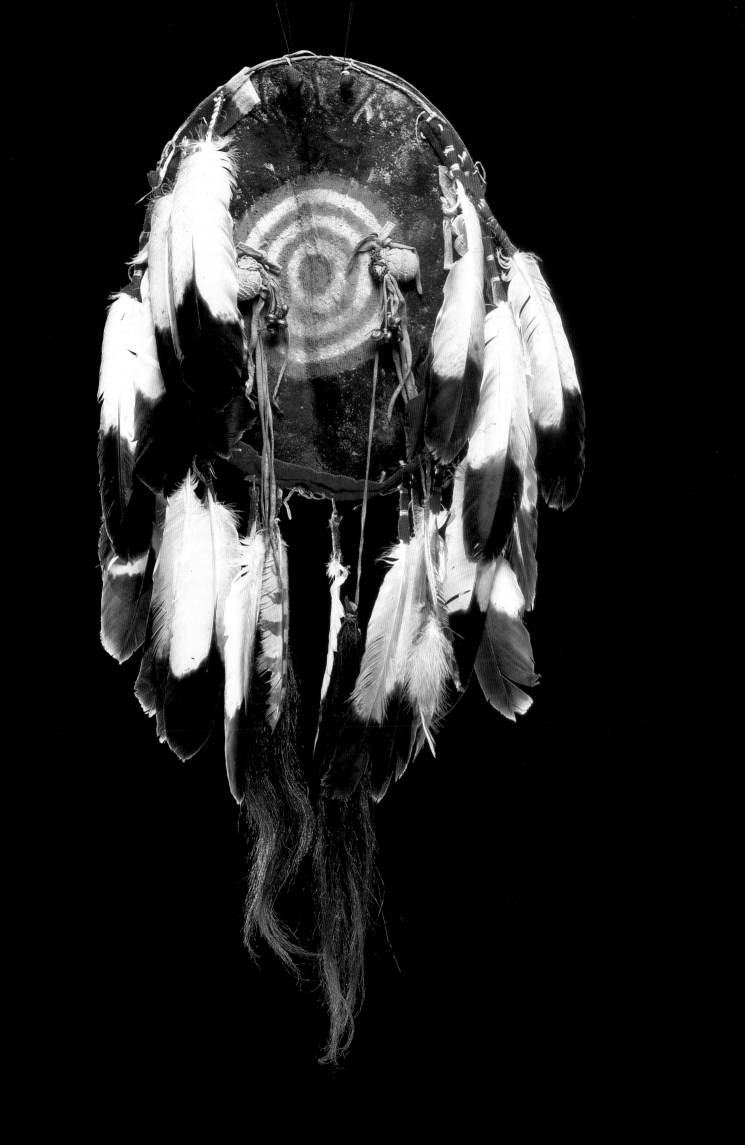

Pipe Bowl

Eastern Sioux

Early 19th century

Ages ago, when the people of the earth all warred against one another, the Creator called all the tribes together at a place called "red pipe." He showed them a smoking pipe made of the red stone found there and smoked it over them saying that the stone was part of their flesh. He explained that although they were at war, they must meet at this place as friends, and if they wished to address Him or appease Him, they must make pipes of this red stone and smoke them in His honor.

The frontier artist George Catlin heard this legend when he visited the great pipestone quarry in southwest Minnesota during the 1830s. In a characteristic gesture of self-promotion, Catlin named the stone "catlinite." The quarry, which was in the Eastern Sioux territory of Dakota and today is protected as a national monument, has always been considered a holy place among many of the Woodlands and Plains tribes. Parties that arrived to take stone spent several days of fasting and praying in preparation. Smoking tobacco in pipes has always been considered an act of prayer in traditional Native religious practice. The Creator gave tobacco to human beings so they would have something to offer in thanks for blessings from the spirit world.

Eastern Sioux men traditionally carved stone, bone, and wood. Individual carvers sometimes specialized in making smoking pipes for sale or barter. If they were talented, they became widely known and their work was highly prized. The literature of early western travel mentions several famous pipe carvers. Although the specific identity of the man who made this one is not known, it is carved in the broad style of Eastern Sioux pipes. Only a small number of this artist's very distinctively sculptured pipes survive today, but all can be recognized by the invariable detail of a buffalo hoof design inlaid in lead visible on the shank of the pipe bowl. The inlay was created by carving out the pattern in the stone and then filling the shallow relief with molten lead. The man who carved this pipe was particularly skillful in his rendering of the expressive figures carved as if they are seated on the shank of the pipe. Here two seated men face each other, the larger presenting a barrel to the smaller. Note the thin, spindly legs, the broad shoulders, and massive chest of the larger figure and the impassive expression on his face.

The meaning of the carved figures is inferred by looking at the history of the fur trade in the northeastern Plains of the early 1800s. The Eastern Sioux controlled vast hunting territories, and hunters harvested thousands of muskrat and beaver pelts every year, goods that brought considerable wealth to their trading partners. The trade was controlled, however, by band chiefs who acted as intermediaries between hunters and traders. It was common practice at that time for fur traders to offer barrels of brandy as gifts and in barter for furs, which were then distributed by Indian leaders to their loyal followers. The large figure with a barrel on his knees carved on the pipe bowl is a fur trade chief represented in the act of presenting brandy to a subordinate. The chief is represented as larger and therefore more powerful and important than the smaller figure. It is possible that the pipe was intended as a presentation piece to an esteemed trader and served as a subtle reminder of how important chiefs were to the success of the trade.

Southern Minnesota or eastern South Dakota.
Stone (catlinite), lead inlay.
Length: 7 1/4 in.
The Masco Art Collection.

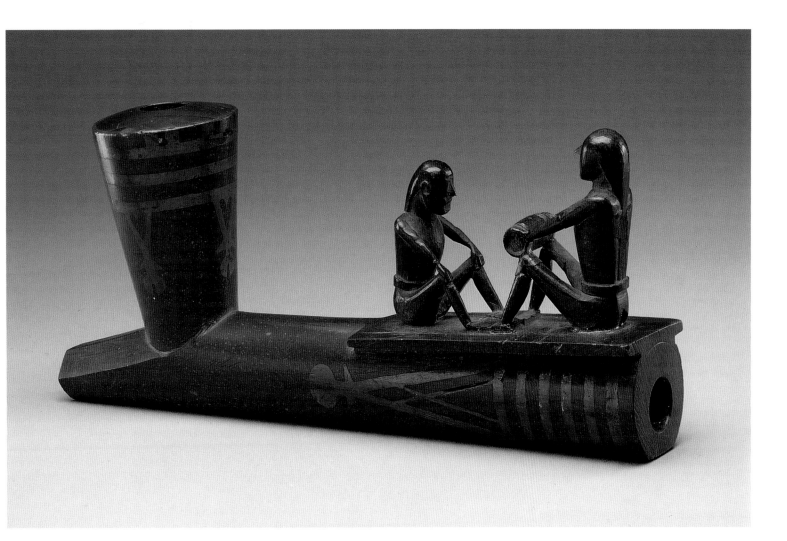

Split-Horn Bonnet with Trailer

Lakota (Western Sioux)

19th century

Among Plains men, the feather headdress represented the consummate symbol of a warrior's prowess. It was worn as a headdress of distinction and accomplishment by men of several different Plains tribes during the nineteenth century, but only by those men who were thought by their community to deserve such a high honor. It was customary for family or friends to present a feather war bonnet to a man who performed some noteworthy feat of personal combat. A feather war bonnet worn in battle signified that the warrior was a particularly brave and tenacious fighter who was prepared to face the enemy with courage and selfless determination.

The success of Plains buffalo hunting societies depended upon the bravery of their warriors. The introduction of horses to Plains culture during the eighteenth century from the New Mexican colonies of the Rio Grande permitted increased mobility for Plains Indian communities and vastly extended the hunting ranges of buffalo hunters. Plains communities competed with one another for prime hunting territories and access to the buffalo herds, reinforcing their claims with military power.

The Lakota were one of the most successful of all the buffalo hunting peoples. Their origins lie in the woods of southern Minnesota, but during the eighteenth and nineteenth centuries Lakota population expanded dramatically and their villages spread across the Plains through the Dakotas to Montana and Wyoming. They became the most powerful people of the Plains and, allied with the Cheyenne, even threatened the westward expansion of the United States. Lakota domination of the northern Plains stemmed from a strong warrior ethic that rewarded bravery in battle and encouraged men to excel in the martial arts.

This Lakota feather headdress is replete with symbols of a warrior's virtues. It is made in a style often seen in the early 1800s, with a row of clipped feathers arranged across the brow between the horns. The horns are fashioned from the split halves of buffalo horn, and the horn ends are wrapped with white ermine fur and hung with pendants made of red-dyed horse tail. Horns on any Plains headdress represent potent spiritual power, and the strips of white ermine fur that cover the cap symbolize the warrior's aggressiveness, since the ermine, or weasel, is such a ferocious predator. Tufts of owl feathers arranged on either side of the cap invoke the quick vision, swift, silent movement, and deadly action of the owl. Sacred hoops with tobacco bundles tied to the center acknowledge the spiritual sanction and blessings necessary to any warrior's success.

The long trailer made of hide is decorated with a particularly impressive set of large feathers from the tail of the golden eagle, the most powerful and sacred of creatures in Plains cosmology. Red-dyed horse tail pendants dangle from the tip of each feather. At seventy-four inches, this strikingly beautiful feathered trailer is longer than the height of a standing man and was therefore intended to be worn only on horseback.

North or South Dakota.
Deer hide, eagle feathers, buffalo horn.
Length: 74 in.
Buffalo Bill Historical Center, Cody, Wyoming.

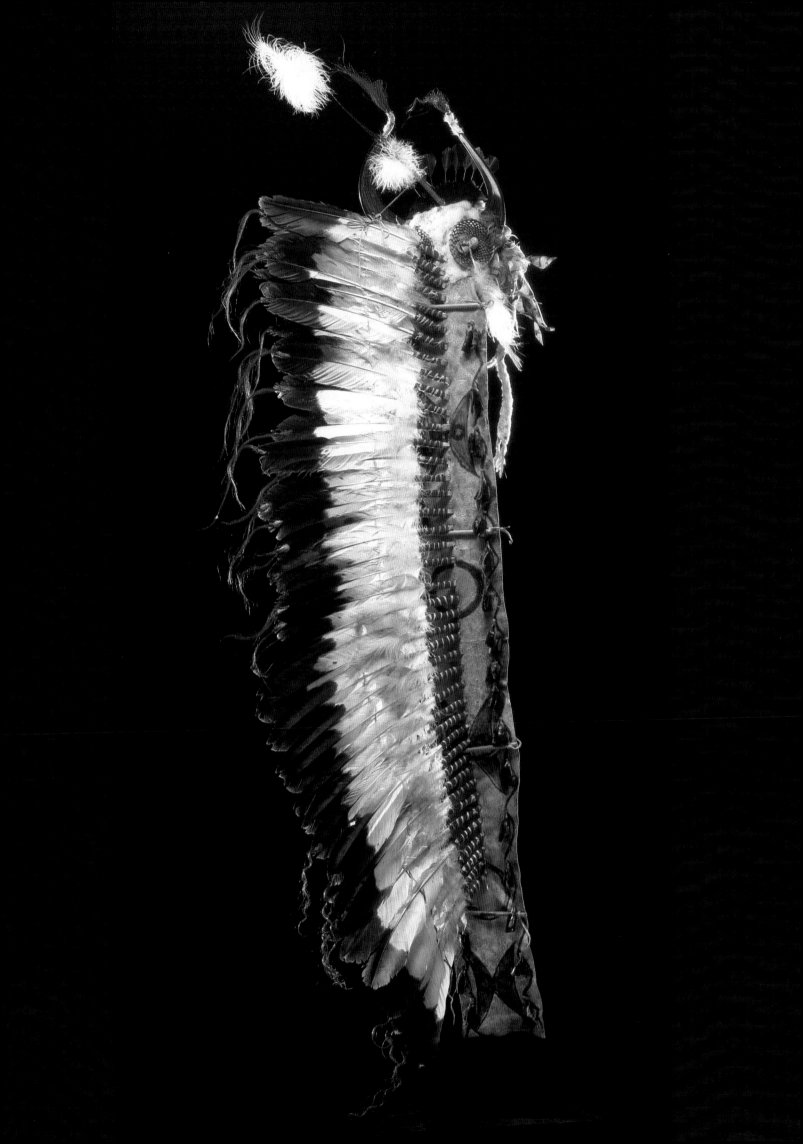

Robe with War Exploits

Unknown Plains tribe

1797–1805

The origin of this painted robe is uncertain, but it undoubtedly comes from one of the tribes of the northern Plains. It was customary for Plains men to paint a record of their war exploits on items of dress clothing, such as shirts, leggings, or buffalo hide robes, which, like this one, were worn around the shoulders. The stories recorded in the pictographic representations are factual, autobiographical accounts sanctioned by witnesses who participated in the same events. When accomplished warriors wore garments such as this one painted with representations of their heroic acts, all who saw knew that they possessed the authority of men who had proven themselves in the highest test of character and resolve.

The war records on pictographic robes were painted in a sparse, abbreviated manner that emphasized the identity of the participants, both friend and foe, their weaponry, and the events that transpired. This robe shows at least ten different episodes of combat involving a man wearing a brown and red striped shirt, red breechcloth, fringed leggings, and a single eagle feather in a roach headdress. Some of the events depicted may have occurred during a single battle. In three instances the warrior is shown carrying a pipe indicating that he was the leader of the war party. The leader was held entirely responsible for the welfare of his party, and he prayed with a pipe for spiritual protection. The rest of the scenes illustrate individual combat involving either the war leader or the members of his war parties. In the upper right the leader is visible holding a pipe and shooting an enemy who holds a rifle. Farther to the left, the same figure is repeated twice, on different occasions, first with a pipe and then confronting a party of enemies with a bow and arrows.

In general, the artist has chosen to represent the moments when the warrior strikes his enemy, each blow counting as a "coup" to his credit. Below the upper register of figures he is seen shooting a fleeing enemy with an arrow, and to the right he strikes an enemy with his bow. He rides down an enemy while astride a yellow horse, or fearlessly faces an enemy who charges at him mounted on a red horse. The lower portion of the robe depicts a particularly significant battle. The leader stands as the pipe carrier in the lower right (beneath the bear), and ordered below him are as many as nine different encounters between his party and the enemy, including one where the leader shoots an enemy who carries a shield and wears a long eagle-feather headdress.

This robe is remarkable both for its wealth of pictographic detail and its dynamically rendered action. Each episode depicts a harrowing experience of personal combat. The owner of this robe, the man identified to us only by his eagle-feather roach headdress, striped buckskin shirt, red breechcloth, and black fringed leggings, must have been greatly revered among his people and feared by his enemies.

North Dakota.
Buffalo hide, dyed porcupine quills, paint.
Length: 102 in.
National Museum of Natural History, Smithsonian Institution,
 Washington, D.C.

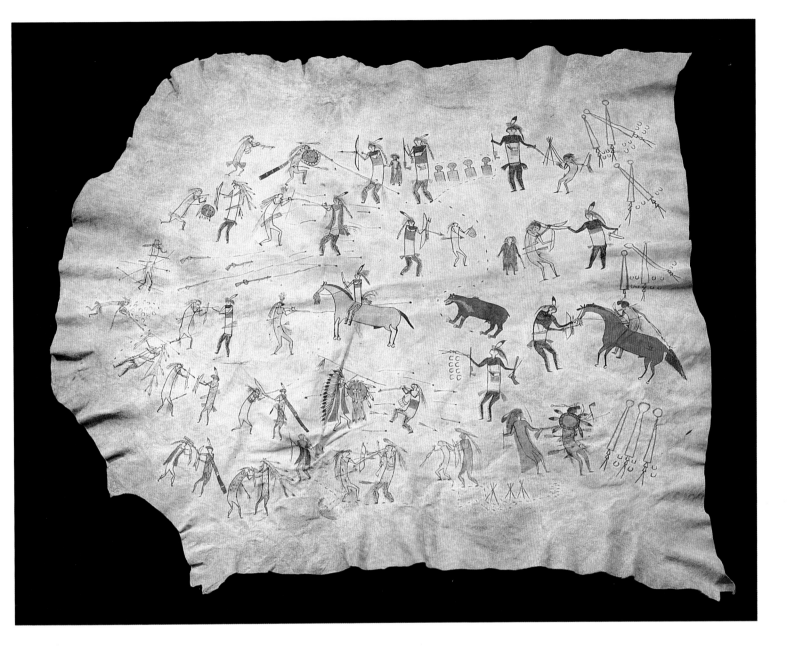

Man's Shirt

Cheyenne

c. 1860

The Cheyenne are one of several Algonquian-speaking peoples who, after having acquired horses, established themselves in the Plains as buffalo hunters. Domestic horses came to North America with the Spanish when they settled the colonies of New Mexico during the sixteenth century. Horses and the knowledge of their usefulness spread quickly to tribal groups to the north, reaching the northern Plains by approximately 1700. Hunting bands expanded hunting territories and moved their villages to follow the wanderings of the buffalo herds. The Cheyenne lived originally somewhere north of Lake Superior, but by the end of the eighteenth century had migrated south and west to occupy the central Plains, hunting buffalo in what are now the states of Colorado, Nebraska, Kansas, and Arkansas.

The designs and decorations on Cheyenne clothing often conveyed specific meanings, and certain patterns could only be worn by individuals who had earned the right to do so. Like their Plains neighbors, Cheyenne people recognized dress clothing as a means of communicating personal and tribal identity. Only a man who had demonstrated his bravery and skill in combat could wear a shirt like this one adorned with hair fringe. The locks of hair arranged as pendants along the shoulders and sleeves symbolize scalp locks (trophies taken from vanquished enemies), although the hair used for this particular shirt was contributed by family members. The white fur on the shoulders comes from the ermine, or weasel, who, although small, is considered one of the most ferocious and tenacious of predators, a worthy model for a warrior. The thin lines painted on the sleeves indicate that this warrior had killed enemies in combat. Not visible in the photograph are painted images of dragonflies who, like skilled warriors, hover within arm's reach but effortlessly avoid harm by darting away from blows aimed at them. When a man wore this shirt, these symbols told of the presence of a warrior who had enjoyed many victories and was recognized as a leader among his people.

Other symbols on the shirt acknowledge that success in life depended upon spiritual blessings. The blue paint used to stain the upper part of the shirt symbolizes the sacred earth, the source of all life. Cheyenne people collected sacred blue earth pigment from a secret source in the northwest Plains, probably a river bank where minerals stained the mud. The red used for the chain of circles that descend either side of the breast represents the power of the life force itself. In the center, partially covered by the beaded neck flap, is the painted image of a swallow, a spirit being that may have had a special and privileged relationship with the owner of the shirt. Spirit beings in the form of animals approached particularly worthy men of the Plains tribes and offered them gifts of power to defeat enemies, to heal the sick and injured, and to protect their own health and well-being.

A woman prepared the hides, tailored the shirt, and added the beaded decoration to the sleeves, shoulder strips, and neck flap. The male owner of the shirt added the painted symbols. Like most traditional Plains women's art, the beaded designs are nonrepresentational and geometric. Men, on the other hand, employed a kind of pictographic visual language to convey more personal and biographical information. The patterns and color preferences used by both makers of this shirt are distinctly Cheyenne in character and thereby signify a strong sense of ethnic identity.

Colorado and Kansas region.
Deerskin, buffalo hide, glass beads, ermine skins, wool fabric, human hair, paint.
The Detroit Institute of Arts.

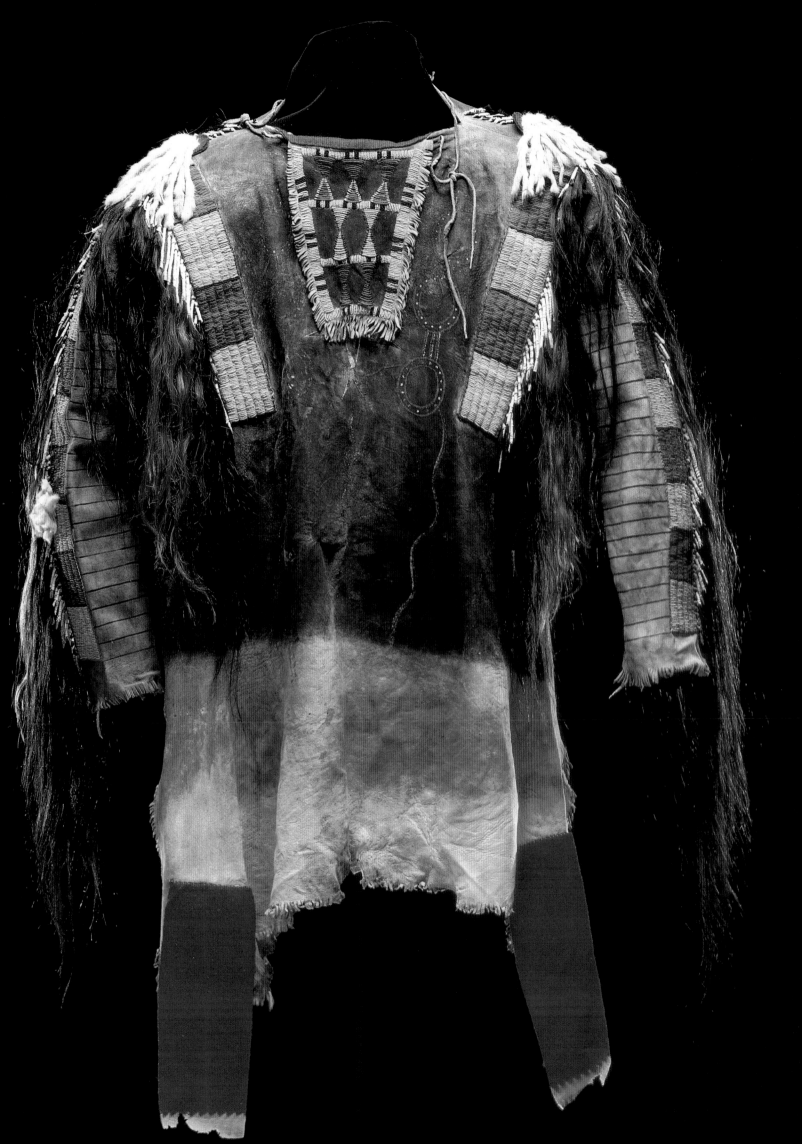

Woman's Dress

Southern Cheyenne

c. 1880

The heart of Cheyenne hunting territory lay adjacent to the Platte River during the mid-1800s. With its headwaters in Wyoming and a broad floodplain that runs the length of Nebraska, the Platte River valley became the axis of European-American migration west after 1850.

After the California gold rush of 1849, the Cheyenne saw their hunting territory cut in half by a mounting tide of settlers. Some of the displaced bands moved north and often camped with their Sioux allies in the Dakotas and Wyoming. Others continued to hunt in Arkansas, Nebraska, and Oklahoma. During the 1860s and 1870s, tensions led to fierce conflict, including the tragic Sand Creek massacre in Colorado and George Armstrong Custer's destruction of Black Kettle's village at Washita, Arkansas, in 1868. Reservation life began with the imprisonment of Cheyenne leaders in 1875 and the capture of the northern Cheyenne in 1876. The southern Cheyenne shared a reservation with the Arapaho, Comanche, and Kiowa that was administrated from Fort Sill, Oklahoma.

On or off the reservation, Cheyenne women who made and decorated clothing were recognized and honored for their skills and accomplishments. Particularly skillful women belonged to a quillworkers association, similar to a guild, that controlled and supervised the art of porcupine quill embroidery. At feasts, women elders were invited to stand up and tell how many robes they had made and decorated, a practice not unlike the way men publicly recounted their victories in battle.

This dress was made by a Cheyenne woman who lived on the reservation at Fort Sill during the late 1880s. She made it with three deerskins, two for the lower portion

of the dress and one for the bodice. The dress was worn with a leather belt decorated with circular medallions of German silver (a nickel alloy) called "conchas." The hide of the bodice was stained with yellow earth paint, which was a common practice among peoples of the southern Plains. The glass bead decoration is subtle and restrained: a strip of bead appliqué across the shoulders, a scalloped band of red and white above the hem, and delicate white stripes with red and blue boxes across the center of the skirt. Most surprising, perhaps, are the cowrie shells sewn in parallel rows across the bodice. The shells, ancient North American symbols of wealth and spiritual blessings, were probably harvested from the coast of Africa and brought to Oklahoma by traders. "Tinklers" of tin cones sewn to tablike extensions of the hem on both sides of the dress add an audible dimension to the decoration. This style of dress became popular, with minor variations, among young women of the southern Cheyenne, southern Arapaho, and Kiowa during the first few decades of reservation life after 1880.

This is a formal garment, not an everyday dress. As formal regalia, the dress was most often worn for dancing. Plains women continued to practice and teach the skills of needlework and hide dressing during the reservation period, and the regalia worn by family members was an expression of cultural pride and social standing. At a time when cultural integrity suffered severely at the hands of the reservation system, the traditions of women's art and dancing regalia contributed greatly to cultural survival.

Region of the Fort Sill Agency, Oklahoma.
Deerskin, cowrie shells, glass beads, tin cones, paint.
Buffalo Bill Historical Center, Cody, Wyoming.

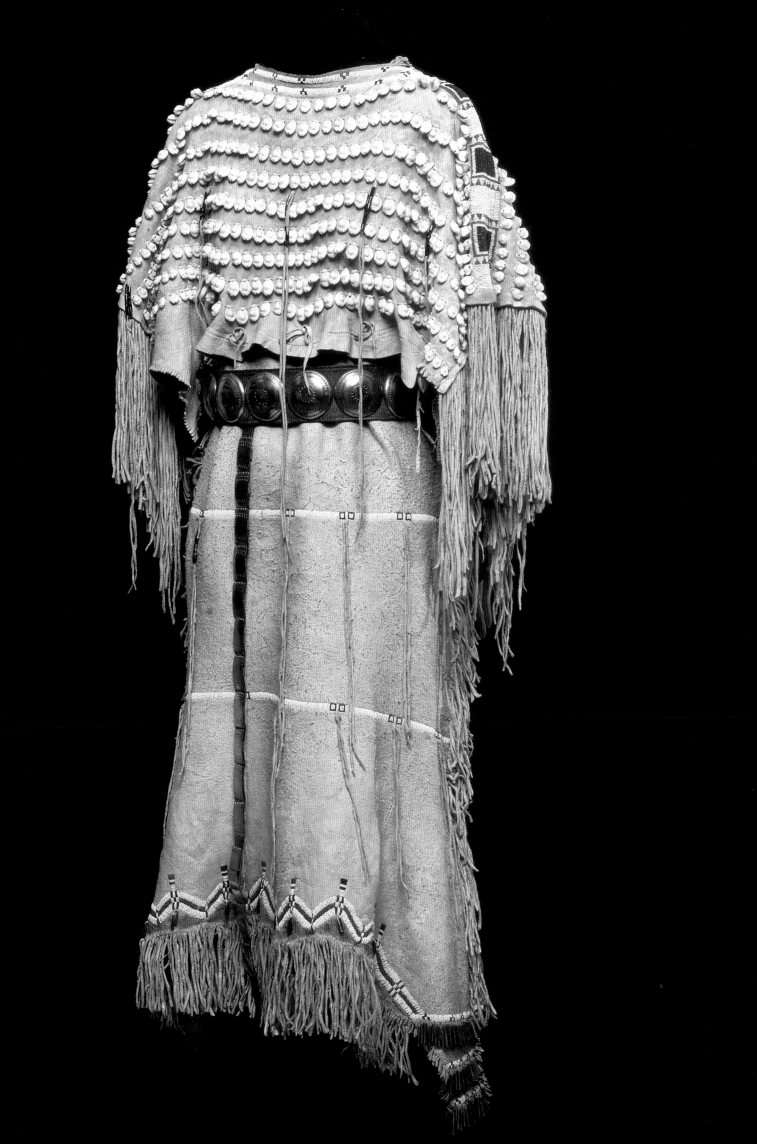

Traveling Bag

Nellie Gates (Lakota/Western Sioux)

1907

Traditional Plains Indian society has always extolled women's abilities to make things. Women were honored for the buffalo robes they prepared just as men were recognized for their accomplishments in battle. When the buffalo died out and traditional warfare on the Plains was forbidden by the authorities after 1880, men lost many of their traditional roles and responsibilities. Not so for women, who continued to pursue the traditions of craft work after the transition to the reservation era. As times changed, women adapted their creations to meet the new requirements of a changing lifestyle. Many talented beadworkers found that they could sell their handwork for cash, which was otherwise hard to come by on the reservation. Women made regalia for their relations, beaded moccasins and other items for "give-aways" at feasts, crafted gifts to honor their friends, took commissions for special items, and sold whatever the trader would buy in exchange for coffee, flour, and other goods.

The early reservation era of the 1880s and 1890s represents an episode of tremendous innovation and productivity in Lakota beadwork. Children's dress outfits, dresses for young girls, and vests with trousers for boys were covered with beadwork patterns from top to bottom. Women even beaded men's ties. Heavily beaded garments and accessories were worn at social dances, fairs, and community festivals such as the Fourth of July celebrations, which, due to their patriotic associations, were encouraged by reservation officials. In addition to items of regalia, women also decorated more unusual categories of objects: a phonograph speaker horn, for example, a violin case, or, as seen here, a doctor's bag. At a time when Lakota culture was threatened by tremendous changes and assimilation, beaded decoration on various kinds of objects and clothing became an art form that reasserted traditional Lakota values.

Nellie Gates was a gifted bead-embroidery artist who lived on the Standing Rock Reservation of North Dakota during the early twentieth century. Since some of her products have her name worked into the beaded decoration, her reputation followed her wares and extended beyond the boundaries of the reservation. Gates, like other Sioux women of her generation, developed a pictorial style of bead embroidery that borrowed scenes of combat or depicted people in regalia in a type of representation that recalled the traditional painting of Plains men. This doctor's bag was made for J. A. Archambault, a resident of the Standing Rock Reservation, and it remained in the Archambault family until very recently. Instead of using the customary geometric designs in parallel stitch, Gates experimented with lively, representational images executed in a flat, "spot-stitch" technique. Here, mounted warriors on horseback flank the beaded inscription.

Standing Rock Reservation, North Dakota.
Commercial traveling bag, glass bead decoration.
Length: 18 in.
The Masco Art Collection.

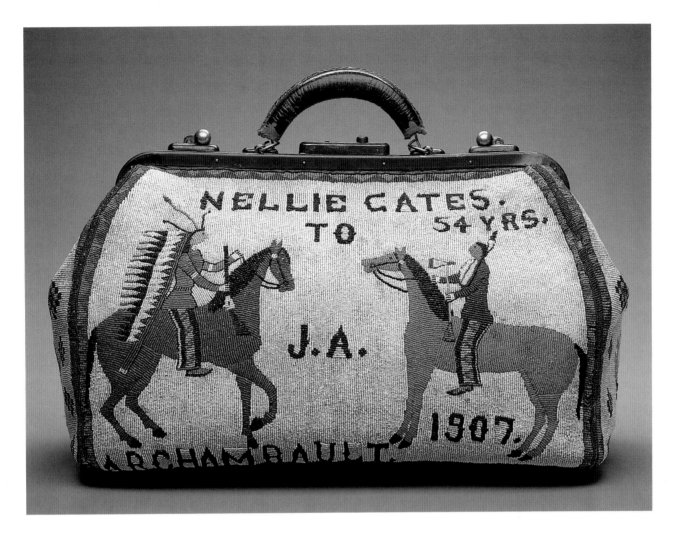

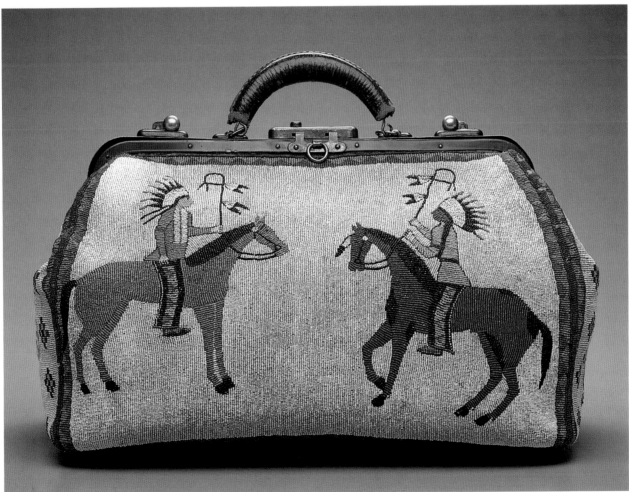

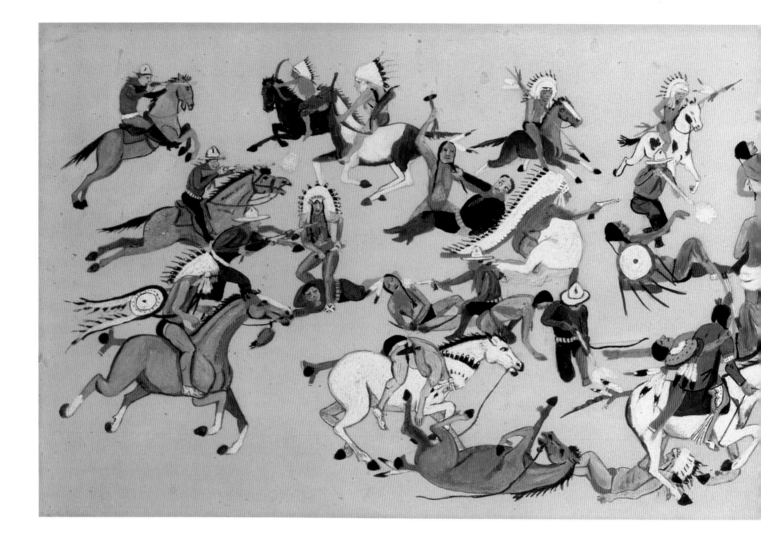

Indians Fighting White Men

Carl Sweezy (Arapaho)

Before 1942

Carl Sweezy, born in 1881, was one of the early generation of Arapaho brought up on the reservation in Oklahoma. Sweezy and his contemporaries experienced the transformation of Arapaho culture under white pressure: from buffalo hunting to corn farming, from collective land ownership to individual homesteads, and from oral teaching traditions to public school education. Starting at an early age Sweezy mourned the passing of Arapaho traditions and practices and sought out knowledge of his proud past from

Arapaho elders. Although he learned to paint and received his first box of paints from a white school teacher, he was for the most part a self-taught artist.

Using watercolors and house paint on butcher paper, Sweezy conceived a record of Arapaho history. The notable American anthropologist James Mooney enlisted Sweezy's help as an informant during his fieldwork among the Arapaho for the Smithsonian Institution and commissioned the artist to produce a series of paintings

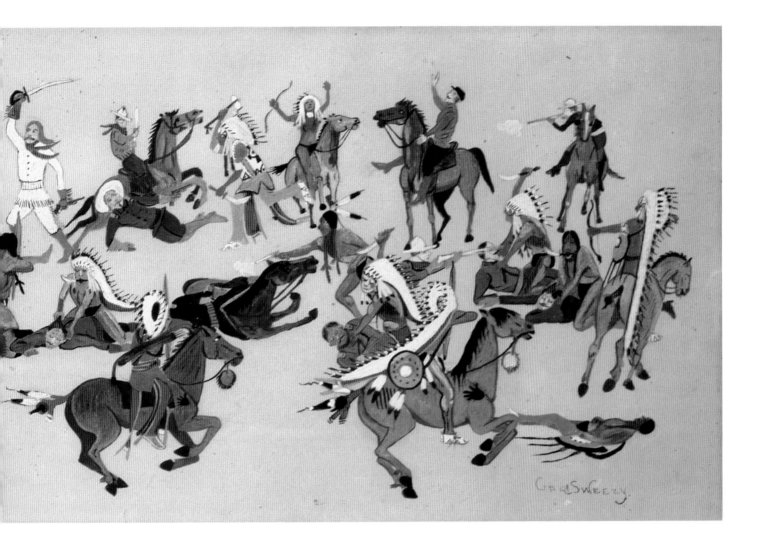

to illustrate traditional Arapaho life. For a time Sweezy was a farmer and a member of the Indian police, but he retired to paint full time in 1920. By then, other American Indian artists such as the so-called Kiowa Five of Anadarko, Oklahoma, and the Pueblo watercolorists of the Taos and Santa Fe area had begun to receive some measure of national recognition and support. Sweezy was one of the earliest among this first generation of American Indian "easel painters," and he established precedents of content and style that many other Native artists would follow.

This large work of mural size is typical of Sweezy's later painting. It illustrates the Battle of the Little Bighorn; the figure in white buckskin standing in the center would logically be George Armstrong Custer. The figures are arranged against a plain background without representation of any environmental space. Sweezy emphasized the action, the combative encounters between individuals that resulted in heroism or death. In this regard, his painting stems from the tradition of Plains pictographic war records.

During the 1880s and 1890s, when Sweezy was just a young man learning from his elders, many Arapaho, Cheyenne, and Kiowa men of Oklahoma were producing pictographic war records by drawing with pencil and paint on paper, often using the bound blank pages of a ledger book or autograph book. These late, reservation period "ledger book" war records provided an important model for Sweezy in the development of his art and brought Plains-style painting into the twentieth century. Ledger book artists drew flattened figures filled in with solid color, but also experimented with foreshortening and the rendering of an illusional space by the rendering of overlapping figures. Sweezy learned these lessons well and painted even more dynamically posed figures foreshortened and overlapping, while continuing to stress the action. Also, while older pictographic art stressed the individual participant, Sweezy portrayed instead the broad sweep of events in a swirling composition.

Housepaint on board.
12 × 38 in.
Photograph courtesy The Heard Museum, Phoenix, Arizona.

Beaded Moccasins with Traditional Floral Motif

Eva McAdams (Shoshone)

1980s

Generations of beadworkers have passed on their skills to younger relations, preserving a tradition of Native American artistry that reaches back to ancient times. The techniques employed and materials used for beadwork have changed greatly, reflecting the influences of the larger world on Native traditions. Glass beads manufactured in Europe have replaced beads made of native copper and shell, and cotton thread and steel needles substitute for awls and sinew. From the seventeenth through the nineteenth century, mission schools introduced pictorial images of flowers to Indian women, who created stunning beaded designs by embellishing their traditional patterns with the new images. Throughout the nineteenth century, variations on the "floral style" of applied ornament entered into the decorative arts of dozens of tribes, from the Malicite on the Atlantic shores of Newfoundland to the Tlingit on the Pacific Coast of Alaska, with each tribe adapting the designs in their own way. Early decorative design had employed geometric and curvilinear elements named for things found in the natural world: geographical features like mountains and rivers, or parts of animals such as otter tails and feathers. Images of flowers seemed a fitting addition to this design vocabulary.

Today, Eva McAdams of the Shoshone tribe of Wyoming continues the floral tradition with this pair of deerskin moccasins made in the traditional Plains pattern. Hard, rawhide soles are stitched to separate deerskin uppers which are brain tanned (a natural tanning technique using tannin from animal brains). The upper portion of the moccasin is attached to the sole by being turned inside out before being stitched up the back. The sewing is thereby protected by being on the inside rather than the outside. The uppers are fully beaded with an even, white background, and a large red rose is framed by delicate green leaves on the vamp.

Although these particular moccasins may have been sold to a collector, they could also have been made as part of modern powwow regalia for dancing. The Native traditions of craft work, regalia, dance, and song are carried forward into the future via the powwow, a kind of inter-tribal celebration featuring dance, song, and socializing that takes place in countless forms in hundreds of cities, towns, and reservations all across the nation every year. Powwows are conducted at special reservation powwow grounds where visitors are welcome to camp nearby, or they may take place in high school gymnasiums, college arenas, or veterans halls. Depending on its scale and reputation, a powwow may attract thousands of Indian people from all over the country, or can be more simply organized as a local social event.

Dancers compete for prize money in several different categories, each with its own distinctive regalia. Among the many dances performed may be traditional dances, fancy dances, the grass dance, and the "jingle dress" dance, with competitors ranging in age from toddlers to seniors. Groups of singers gathered around a large, horizontal drum provide appropriate songs for the dancing. Veterans' songs acknowledge the sacrifice of those who have served their country, honor songs single out those worthy of recognition, and cash can be raised for the needy with a blanket dance. Today, talented women and men continue to employ traditional craft techniques to make powwow regalia for loved family members and friends, just as their ancestors did in generations past. To dance at a modern powwow wearing fine moccasins such as these by Eva McAdams would indeed be an honor.

Deerskin, rawhide, glass beads.
Private collection.

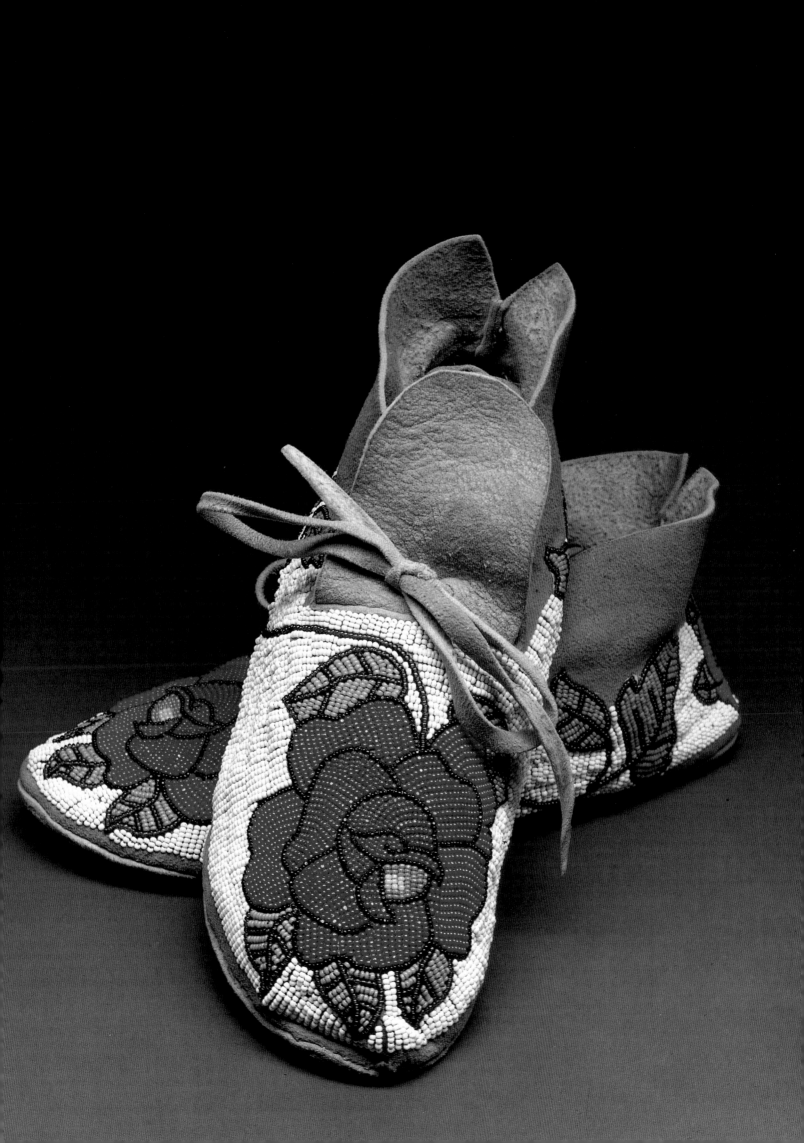

Cache of Ritual Figures

Mimbres culture

A.D. 1150–1400

Although the American Southwest offers only the most tenuous opportunities for cultural life, the region has nurtured the growth of some of the most enduring native cultures of North America. People have lived in the Southwest for more than ten thousand years, mostly as bands of hunters and gatherers who circulated through large "catchment territories" to harvest seasonally available resources. During the centuries after approximately A.D. 300, many of the residents of the Southwest began to experiment with cultivated food plants, such as corn, squash, and beans, introduced by their Mexican neighbors to the south. By approximately A.D. 800, many communities had traded their migratory lifestyle for a more permanent existence in villages where crops could be tended more efficiently.

Early villages were composed of "pit-houses," structures built over squared, semisubterranean chambers where the surrounding earth provided effective insulation against the heat of summer and the cold of winter. Southwest farmers selected their village sites carefully, trying to choose areas where the availability of water and abundance of rainfall, along with the length of time between frosts, optimized the growing season in which their favored crops could mature. Generally speaking, lower elevations featured longer growing seasons but less rain, while sites with higher elevations offered more rain but longer winters.

The Mimbres valley provided one of the best locations for village life in the central Southwest. With its headwaters in the Mimbres mountains of southwest New Mexico, the Mimbres River winds down to a floodplain to the southeast until it disappears into the desert close to the Mexican border. The region was inhabited by a people known as the Mogollon culture, whose range extended throughout the central Southwest. The

Mogollon of the Mimbres valley developed the largest villages and most impressive art forms in the region and in this regard can be considered exceptional.

Little is known about Mimbres religious life and symbolism beyond what can be inferred from the lives of the historic Pueblo peoples of the Southwest who lived many years later. Undoubtedly, concern with rain and agricultural success dominated religious practice. In very broad terms, people of the Southwest saw themselves as part of a larger community of beings which included animals, spirit beings, ancestors, and the land itself, all of which were inextricably bound together. Religious ritual customarily included the offering of gifts to the spirit world as an expression of gratitude for the blessings of life.

This unusually well-preserved cache of wooden and stone effigies was probably intended as an offering, placed in some remote location such as a shrine located in a cave or on a secluded mountain ledge. The objects were found in a plaited basket or wrapper. The covering protected the delicate painted surfaces of the wooden figures. The significance of the cache is lost, but the images of the mountain lion and the curved throwing sticks suggest that the offering may have been intended to assist with the spiritual requirements of hunting. Few collections of figurines such as this have survived and in all likelihood they were not intended to. Like offerings of the historic Pueblos, their function as gifts to the spirit world was fulfilled when they eroded away to dust.

Cliff Valley area, New Mexico.
Wood, stone, cotton, feathers, fiber, paint.
Height of tallest: 25 in.
The Art Institute of Chicago.

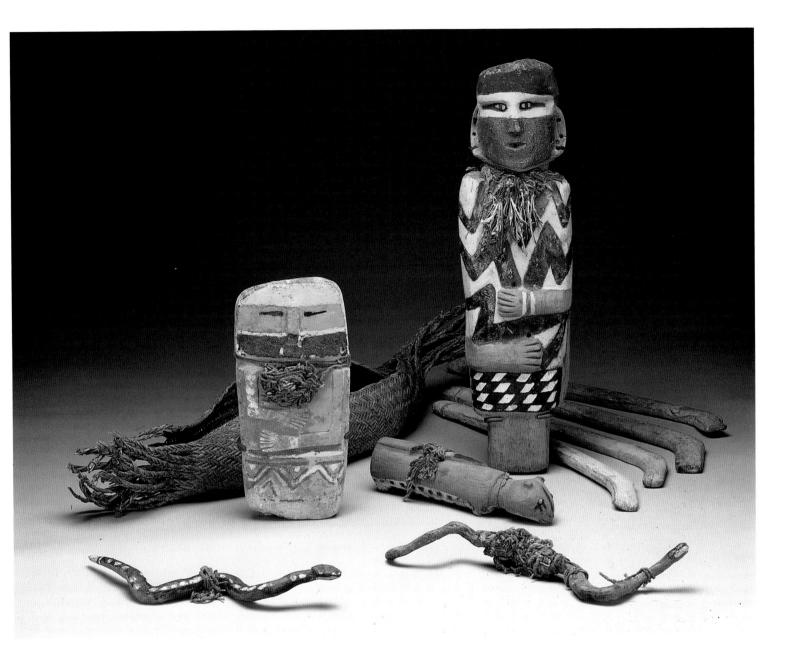

Black-on-White Bowl

Mimbres culture, Mogollon tradition

A.D. 900–1100

The villages of the Mimbres valley reached a peak of development during the eleventh and twelfth centuries A.D. This so-called classic period saw the construction of massive apartment complexes composed of dozens of contiguous rooms. In some villages room "blocks," as archaeologists call them, numbered over one hundred individual chambers. The rooms were constructed of cobble and adobe masonry covered with a mud plaster. Upright posts of pinion pine supported a flat roof fabricated in the typical Pueblo fashion, with logs, red willow saplings, and mud plaster. The Mimbres River was harnessed into the service of irrigation, and Mimbres culture enjoyed an episode of growth and stability that was never again to be matched at that location.

Mimbres room blocks were probably inhabited by related kin, and it was their practice to bury deceased family members beneath the floor of the apartment. The dead were often accompanied by offerings, which included in many cases painted pottery bowls. Pottery had been introduced to the Mimbres area from the south by approximately A.D. 200, with simple painted pottery becoming common during the seventh century. The classic black painted designs against a white slip were not produced until about A.D. 800. These early black-on-white pottery designs were predominantly geometric, nonrepresentational patterns, but figural images of animals and human beings were seen with increasing frequency through the eleventh century. Classic Mimbres figurative painting on pottery bowls as seen here was a development unique to classic Mimbres culture since there is no evidence of any comparable figure painting tradition and pottery anywhere in the Southwest. Most Mimbres figural bowls have been recovered from burials, although they very likely functioned in some capacity in Mimbres households long before they were buried with the dead.

The interior of this classic period bowl is painted with a winged creature that combines the attributes of a human being with those of several different animals. The creature has the antlers and ears of a deer and the tail and posture of a horned toad, along with rectangular wings painted with checkerboard squares. In Mimbres art, animals, human beings, and composite creatures seem to relate to mythic narratives of a religious nature, but their specific meaning remains unknown. Who are these creatures and what was their significance? Do they signify clan affiliation? Are they culture heros who played a role in Mimbres mythology? Do they represent, by way of metaphor, cultural values or religious practices? The painted bowls reveal how the Mimbres understood the cosmos and translated that knowledge into a rich visual language no less compelling for its mystery.

Mimbres valley, New Mexico.
Ceramic.
Tony Berlant Collection.

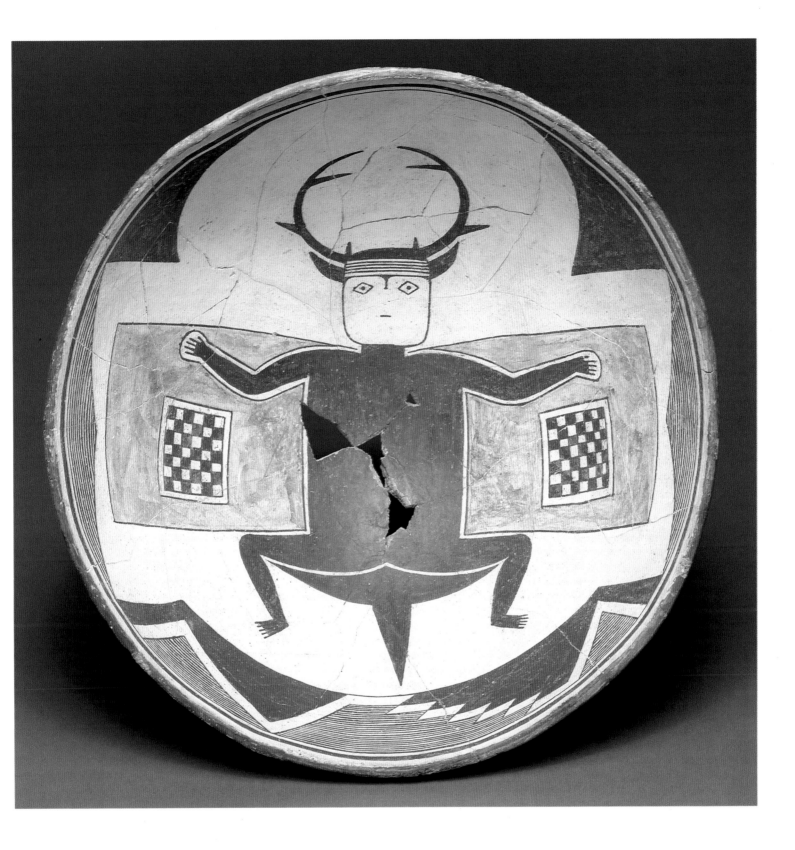

Water Jar

Zuni Pueblo

1825–1850

Zuni Pueblo is located in western New Mexico on the Zuni River, a tributary of the Little Colorado, in an area distant from other pueblos. The Spanish first encountered the Zuni living in six villages, or pueblos, the most prominent being Zuni and Hawikuh. These were mistakenly reported as the "seven cities of Cibola," which were seen from a distance during an initial visit by the Franciscan Priest Marcos de Niza, and news of which inspired Francisco Vásquez de Coronado's conquest of Hawikuh in 1540. The Zuni lived under Spanish rule until their participation in the Pueblo revolt of 1680. Thereafter, the Zuni abandoned their pueblos, fearing Spanish reprisals. Only Zuni Pueblo was reinhabited later: the other five pueblos were permanently abandoned.

This water jar was made by a Zuni woman during the early nineteenth century and was probably used daily to collect water from the Zuni River. It was made with a voluminous, squared body, a shallow, conical base, and a flaring neck. The base is "dimpled" so that a woman could carry the vessel on her head. The jar is divided into three zones—base, body, and neck, each with its own distinctive decorative treatment. The conical base is painted plain red, and the body and neck patterns remain independent and separate from each other. A broad stepped band filled with fine line hatching meanders across the wide, convex body of the jar, outlining stepped triangles, recalling clouds, as perches for delicate butterflies. The stepped triangles, based upon the form of a rising thunderhead, refer to rain, which was so necessary to cultural life in the Southwest. And the migratory butterfly reinforces the theme since butterflies arrive in the Zuni region along with the rainy season.

Zuni women learned pottery-making techniques from their elder female relations. It was a complex process, from the collection of clay at special quarrying sites, to grinding the clay, mixing it with temper and water to obtain the proper consistency of paste, and carefully molding the vessel shape by hand from ropes of rolled clay without the use of a potter's wheel. The vessel walls were then smoothed and burnished, and finally the jar was fired, along with other vessels, on an outdoor fire, which was carefully controlled to maintain the correct temperature.

The designs were painted on the pots between the burnishing and the firing stages. While the method for making the pots was carefully prescribed, decorating them was a purely creative process. "Designs for pottery will come to you in your dreams," the elder women told their students, and no more specific instruction was given. Curiously enough, Zuni girls always dreamed of Zuni pots. The relatively conservative nature of Zuni pottery design, despite its source in personal vision, stands in stark contrast to more modern ideas about personal expression and creativity. Strongly held community values shaped each Zuni individual so that any sense of personal freedom and individuality was bounded by the needs and expectations of the community. Zuni pottery design, with countless individual variations on its conservative design principles, tells us much about the collective character of Zuni society.

New Mexico.
Ceramic.
Height: 12 ¾ in.
The Brooklyn Museum.

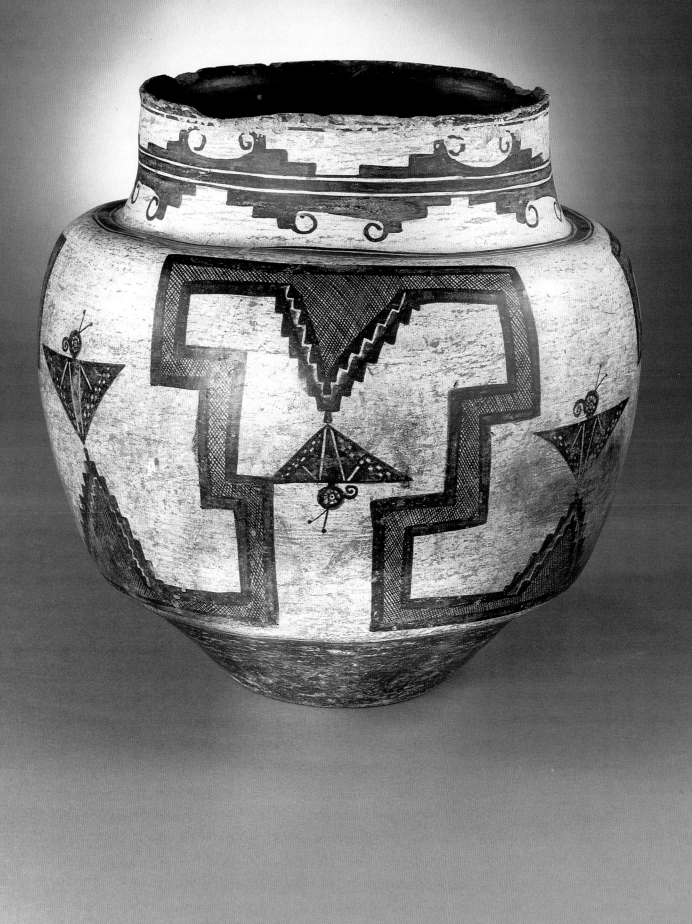

Shalako Kachina

Zuni Pueblo

Early 20th century

Each member of Zuni Pueblo belongs to one of six kivas—a term that refers both to the organized religious groups and the architectural structures in which they meet. Membership in the kivas is determined at birth but is independent of clan or family affiliation. Thus, the kiva groups cut across certain natural boundaries and integrate members of different clans in cooperative responsibilities and endeavors. The kivas perform a number of religious tasks, not least of which is organizing kachina performances throughout the year in a sequence that follows the agricultural cycle.

Kachinas are masked impersonators of ancestors who live at the bottom of a sacred lake two days walk from Zuni Pueblo. Ancestors of today's Zuni are believed to have emerged from this lake onto earth. Those Zuni relations left behind visit Zuni Pueblo annually as kachinas, now impersonated by dancers who belong to the kiva organizations. The kachinas also symbolize clouds and the annual rains necessary for agriculture. There are over one hundred different kachina identities, each participating in different stages of the ritual cycle keyed to the agricultural year. The kivas must organize the annual schedule of kachina dances, produce masks and costumes, train young new members, rehearse, and finally, on the appointed day, stage the performance.

Every year, in late November or early December, the six Shalako kachinas cross Zuni River and enter into the ceremonial plaza on the south side of Zuni Pueblo. The Shalako are couriers for the priests of the kachina village, and their arrival announces the renewal of the annual cycle of kachina dances. There is one Shalako for each of the six kivas. The Shalako impersonators are designated during the previous season and spend the year performing necessary rites and living under certain ceremonial restrictions. The performance is the culmination of their year-long responsibilities. The impersonator is hidden beneath Shalako's garments and supports the head of Shalako atop a hand-held pole so that the kachina towers over eight feet tall.

This kachina doll represents one of the Shalako, wrapped in a decorative manta, or embroidered shawl. Traditionally, kachina dolls are given to children in order to teach them the myriad identities and characterizations of the kachinas. As adults, these children will help organize the kachina performances themselves. Zuni kachina dolls are customarily dressed like this one in miniature garments. This doll is notable for its attention to detail and the fact that it represents one of the Zuni's most important and impressive kachinas.

New Mexico.
Wood, nails, muslin, wool yarn, fur, horsehair,
 feathers, leather, paint.
Height: 45 in.
Southwest Museum, Los Angeles.

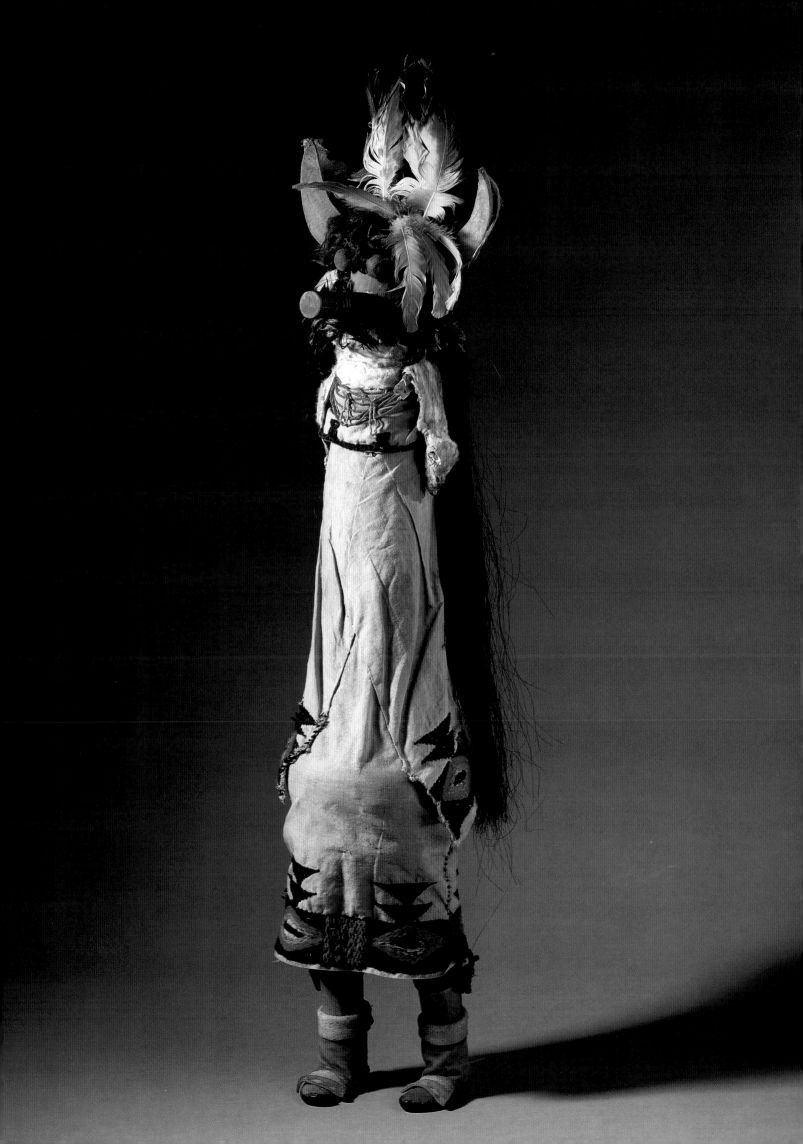

Jar

Margaret Tafoya (Santa Clara Pueblo)

c. 1984

Margaret Tafoya of Santa Clara Pueblo is one of the greatest Pueblo potters of recent times. Born in 1904 to potter Sarafina Tafoya, Margaret learned the art of making pottery by sitting at her mother's side, watching and playing with the clay as Sarafina molded the large, squat-shaped storage jars with elegant flaring necks for which she is famous. After her marriage to Alcario Tafoya in 1924, Margaret lived with her mother and father, which is customary at Santa Clara, and all produced pottery together. Their clients were often tourists who wished to purchase traditional Pueblo pottery to take home with them as mementos of their journey to the Southwest. The Tafoyas have brought their creations to traders in Taos and Santa Fe for more than half a century. Over time, their work has developed a devoted following of admirers and collectors.

Margaret and Alcario developed, and Alcario now executes, the technique of carving designs into the side walls of pottery prior to firing. Like other artist teams of the early twentieth-century Pueblos, teams like Julian and Maria Martinez of San Ildefonso, both husband and wife collaborate to make and decorate pottery. Men played little or no role in the production of pottery before the turn of the century, but since then men clearly have assumed an important role in the creation of "art" pottery for outsiders. Younger descendants of Margaret Tafoya and her relations, both male and female, maintain the traditions today, and the continued excellence of their work has made the family something of an artistic dynasty at Santa Clara Pueblo.

This jar is the traditional polished black-ware distinctive to Santa Clara. This example has no carved designs, just the pair of simple, impressed "bear paw" motifs placed

high on opposite sides of the shoulder over the jar. The low, elegant shape with its smoothly rounded shoulders and graceful proportions is characteristic of Margaret's mature work, hallmarked by her mastery of the technique of building the slanted side walls out to prevent their collapse prior to firing. The surface is burnished to a luster that resembles polished metal. The signature "bear paw" design impressed on the side wall is found on many of Margaret Tafoya's pots, an understated ornament that emphasizes Tafoya's interest in the aesthetic of form and luster rather than surface decoration. It is also the imprint of a genealogical legacy, a tribute to her mother Sarafina, who employed the same motif on her pots.

Carved and polished earthenware.
Height: 7 ½ in.; diameter: 14 in.
Museum of International Folk Art, a unit of the Museum of
New Mexico, Santa Fe.

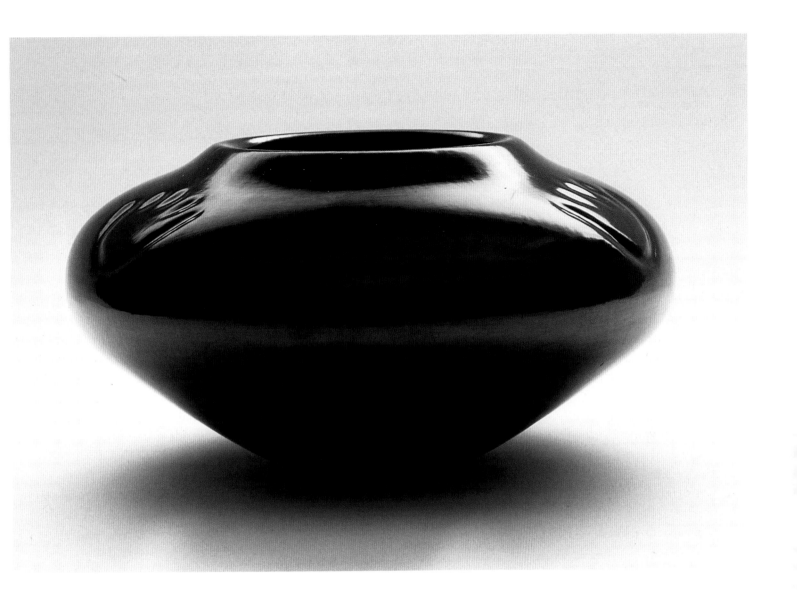

The Emergence of the Clowns

Roxanne Swentzell (Santa Clara Pueblo)

1988

The Institute of American Indian Art in Santa Fe has become highly influential in determining the direction of American Indian art in the contemporary art world. It was founded in 1962 partly as a reaction to the earlier and equally influential Studio School established by Dorothy Dunn in 1932. While the Studio School advocated a kind of simplistic and collective "traditional" style of American Indian painting, the Institute of American Indian Art worked to reassert the creative potential of the individual artist without imposing a restrictive, stylistic agenda. Many successful artists of Native American ancestry working today studied at the IAIA, and the training and motivating philosophy of the school, although having undergone changes from time to time over the last thirty years, has done a great deal to shape contemporary Native American art.

Roxanne Swentzell was raised within the Santa Clara traditions of pottery-making (the same Pueblo is home for the Tafoya family), but her work took a far more personal direction after she attended the Institute of American Indian Art. Swentzell's pieces are coiled by hand in the time-honored manner, but they are animated by a unique sensibility and vision. Her mastery over the techniques of Santa Clara pottery permits their ambitious application to large, figural sculptures that are filled with movement and expression. And her themes often stem from her reexamination of Santa Clara traditions in light of their survival in and adaption to the modern world.

With this sculptural group, Swentzell illustrates an episode of the Tewa creation story (Tewa is the language spoken at Santa Clara), when the Koshare, or ritual clowns, emerged from the Underworld. The origins of Tewa society lay beneath a sacred lake far to the north,

where it was always dark. To emerge into this world successfully, certain members became leaders with special responsibilities. There were chiefs, whose authority alternated seasonally between winter and summer, War chiefs, the Women's Society, and the ritual clowns, Kossa and Kwirana, whose purpose was to entertain the people when they became tired or unhappy.

At Santa Clara, the Kossa (known more generally as Koshare) are the most active of the two Tewa clown organizations, with their distinctive striped markings. They organize ceremonial dances and control the assembled crowd, amusing everyone all the while with their humorous behavior. The Koshare act as intermediaries between the people and their ancestors. They protect traditional values by ridiculing social deviance, and their humor also teaches that the foibles and failings of human life should be regarded with forbearance. Swentzell modeled these striped forms straining and stretching at the moment of their birth into the terrestrial world. The lifelike movements and expressions bring this mythic moment into a believable present, humanizing the miracle of the beginning of the world just as the Koshare humanize, through their antics as ritual clowns, the most solemn moments of Santa Clara ceremony.

Coiled and scraped clay.
Heights: 7 to 23 in.
The Heard Museum, Phoenix, Arizona.

Serape-Style Wearing Blanket

Navajo

1870s

The Navajo arrived at their present homeland of the Colorado plateau of northern Arizona via migration sometime during the fifteenth century. The closely related Apache accompanied them into the region. Both peoples lived by hunting and gathering wild foods, unlike the resident pueblo dwellers of the Southwest, who were farmers.

The Navajo proved particularly adaptable to the economic and cultural opportunities offered by their Pueblo and New Mexican neighbors. Although the Navajo never became farmers, they cultivated orchards of peach trees introduced from Mexico and assembled large herds of horses and flocks of domestic churro sheep. They wove the rich churro wool into fabrics using an adapted Pueblo design of upright loom. It is not possible to determine exactly how or when the Navajo learned Pueblo weaving techniques, although Spanish records of the eighteenth century do mention Navajo weavings and trade in Navajo textiles. Navajo weavers made blankets and *mantas* (women's wrap-around dresses) for themselves, but also traded them to several neighboring peoples, particularly Pueblos and Utes. A style of striped wool blanket known today as a "chief's blanket," developed by the Navajo in the nineteenth century, became a highly valued commodity sought out by prominent and wealthy members of many distant tribes.

Another popular category of wearing blanket strongly influenced by New Mexican blanket patterns of the Rio Grande region is known as the "serape style." This is something of a misnomer since Mexican serapes are cut with a slit in the center for the head and worn hanging down in front and back, while Navajo serape-style blankets are made with no slit and are worn horizontally around the shoulders. The design relationship between true Mexican serapes and this category of Navajo textile

lies in the use of stepped triangles and diamonds in the patterning. The mid-nineteenth century represents a high point for the production of these wearing blankets, a kind of "classic" period in Navajo textile weaving.

Although the serape-style blanket is woven on the loom vertically, it is designed to be worn horizontally so that all the stripes run up and down the body. As is seen here, the pattern is composed in three parts: a central panel framed by two identical, symmetrical panels on either side. When worn, the central panel falls down the center of the back while the two identical outer panels wrap around the body and meet in front. The central panel and side panels are based on the relatively simple concept of a central "core" composed of vertical rows of stepped diamonds enclosed by stepped, zig-zag stripes in alternating colors. The areas filled with narrow lines seem to recede into a background so that elements of solid orange, white, red, and green float above them. The weaver developed subtle patterns by shifting colors throughout the design. It was customary during the 1850s and 1860s to mix different kinds of yarn in trade blankets. This blanket combines homespun, commercial three-ply twisted yarns, and even yarns unraveled from commercially woven woolen cloth. The pale orange and green represent the early use of commercially available colors, a practice that would become increasingly common in the later decades of the nineteenth century.

Arizona.
Cotton warps, wool yarn.
Length: 76 in.
The Detroit Institute of Arts.

Sandpainting Weaving

Navajo

Early 20th century

During the early twentieth century, most Navajo weaving was intended for outside markets. Anglo entrepeneurs at trading posts within the Navajo Reservation worked closely with weavers to develop categories of weaving and design that would appeal to outside buyers. Weaving production shifted from blankets to rugs, some of them based on Turkish carpet patterns provided by traders. Another style that proved very popular with Anglo buyers incorporated figural images employed by Navajo healers in sandpaintings. Sandpaintings possessed sacred, healing powers and were destroyed the same day they were completed. Although many Navajo felt uneasy about borrowing sandpainting imagery for weavings, figures drawn from sandpainting compositions were commercially desirable and began to appear in the work of Navajo weavers during the final decades of the nineteenth century.

Sandpaintings are made for a ceremony called a "chant," which is the recitation of part of a long story about the beginnings of the world. The sandpaintings are at once illustrations of the story and the "gifts" that are given to the heroes of the story. The narrative, its sandpaintings, and other details of the healing ritual are the property of a "singer," or healer. When someone falls ill, the singer is hired to create sandpaintings linked to different events of the narrative depending upon the diagnosis of the ailment. Generally, a sandpainting ceremony will employ only four sandpaintings at most, representing only a small fragment of the entire narrative. The painting itself is produced with dry pigments mixed with sand on the floor of the patient's home. When it is completed, the patient sits in the center of the painting and the singer and his assistants rub the sand on his or her body to apply the healing powers of the images.

This weaving illustrates a sandpainting from the Shooting Chant, one of some twenty to twenty-five different Navajo chants. Shooting Chant is particularly effective against diseases caused by lightning and protects against arrows and snakes. The chant narrative begins with the time when Changing Woman lived in difficult, nearly barren land filled with dangerous monsters. Dripping Water and Sun impregnated her with twin boys named Slayer-of-Alien-Gods and Child-of-the-Water, who were to rid the world of these evil beasts and make it fruitful. The myth then recounts the adventures of the twins and their encounters with Holy People who would help them. The painting illustrated on this weaving is called "The Skies" and was taught to the twins by the Sun, their father, at Dawn Mountain.

The image shows the four skies of a single day and their directional orientations: the white sky of dawn to the east, the blue sky of day to the south, the yellow sky of twilight to the west, and the black sky of night to the north. Each of the four skies is represented by a trapezoidal shape of the appropriate color. The horned faces toward the center of the composition represent the blue sun, the black wind, the white moon, and the yellow wind. In each corner is one of the four sacred plants recognized by the Navajo: corn, tobacco, squash, and bean. Like many sandpaintings, the composition is radial, growing outward from the center. This weaving has no healing power; only the sandpainting, executed and used properly by the healers, is sacred.

Northern Arizona.
Wool yarn.
Length: 123 1/2 in.
Tony Berlant Collection.

Burnt Water Rug

Victoria Keoni (Navajo)

1985

Toward the end of the nineteenth century, the market for Navajo weaving grew rapidly among Anglo buyers. Traders living on the Navajo Reservation in northern Arizona played an instrumental role in developing the market and increasing sales. They worked closely with the weavers in their area, encouraging quality and often suggesting marketable patterns and designs. Since Anglo buyers showed little interest in blankets, traders introduced weavers to the concept of rugs, which were more variable in size than blankets and often included borders as part of the pattern. Since Anglo buyers desired "authentic" and "natural" Indian art, traders at the turn of the century discouraged Navajo women from using bright, commercially dyed yarns, preferring instead white, grays, and browns. Traders narrowed the design choices for weavers, issuing catalogues illustrating the most popular patterns. In a sense, the traders developed a kind of cottage industry in which weavers lost much of their individuality.

Today, Navajo weavers are much less controlled by traders, and women are better paid for their work than they were in the past. In many instances, traders now see themselves as collaborators who work to encourage the creativity of weavers. The trader-dominated market system of years back is now history, and today's weavers enjoy the freedom to express themselves in ways that combine tradition with innovation.

This carpet, made recently by weaver Victoria Keoni, shows many of the historic layers of Navajo design that developed under the influence of traders. The geometric composition of the rug, with its central diamond and a triangle set in each of the four quadrants, derives ultimately from the patterns of Turkish and Anatolian carpets introduced by trader J.B. Moore at his Crystal River Trading Post in northern Arizona during the first decade of the twentieth century. Moore showed these patterns to Navajo weavers and inspired them in a whole new direction. The central panel of Keoni's rug contains images of *yei* figures drawn from Navajo sandpaintings, sacred imagery that was introduced to weaving by traders as early as the 1890s. Much more recent in inspiration is the soft, pastel color-scheme visible in this carpet. Some enterprising traders of recent years have sought out "dye artists" from the Burnt Water region (hence the name of the rug) to prepare yarns for Navajo weavers dyed with natural mineral and vegetal dyes. The rug then becomes a true collaboration between the dye artist, the weaver, and the trader who commissioned the piece. The subtle lavenders, pinks, and gentle orange hues are a new development in Navajo weaving, and can be viewed as yet another chapter in this ongoing, dynamic history of creative innovation.

Wool, dyes.
36 × 46 in.
The Heard Museum Gift Shop, Phoenix, Arizona.

Seven Ketohs

Navajo

1890–1920

Atsidi Sani, a Navajo man trained as a blacksmith, is credited with being the first Navajo to make silver jewelry, a skill he developed after training with a Mexican blacksmith in 1853. Sani thereafter taught several other Navajo the techniques of silver work to establish what has become one of the best known Navajo arts traditions.

The earliest Navajo silver work, although elegant, was necessarily simple, a result of the basic metal working techniques employed. At first, melted silver coins cast into ingots provided the raw material. Silver workers made simple bracelet bands by hammering and grinding the small ingots into shape, and applied additional surface ornament with files and chisels.

The number of Navajo silversmiths increased after the United States military removed the Navajo forcibly from their homeland in northern Arizona and imprisoned them at Bosque Redondo in 1863. The reservation

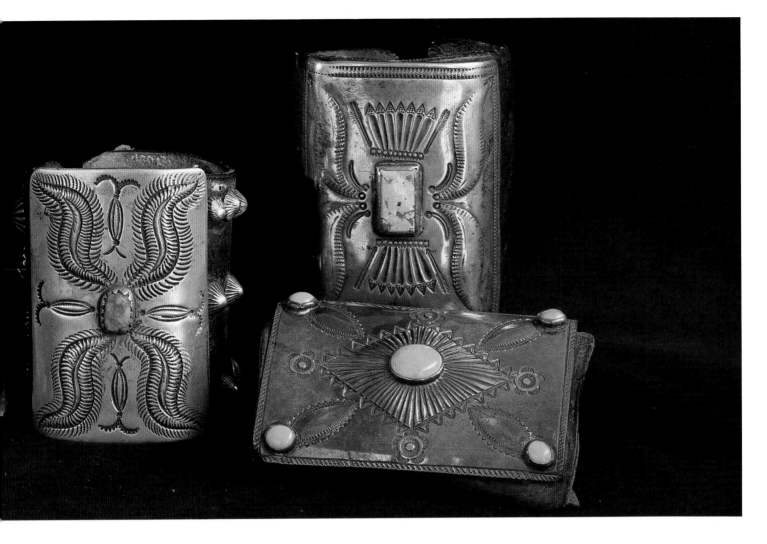

offered few economic opportunities, and many people turned to craftwork to increase their chances for survival by making things to sell. Women concentrated on blankets and other textiles. Many men learned the skills of silversmithing. After the Navajo were allowed to return to Arizona in 1868, silver production continued to increase. Silver jewelry circulated throughout the Navajo community through gift and trade, and later, during the 1880s, Navajo silver jewelry found a new market among the Anglo visitors to the region.

Navajo silversmiths continued to explore new techniques during the 1880s and 1890s. Stamps with more elaborate patterning supplemented filed and chiseled surface ornament. The technically difficult task of soldering permitted the creation of beads, squash blossom pendants, and bezels for inlaid stone, and turquoise inlay became more common. By 1900, traders specializing in marketing to Anglo tourists supplied Navajo smiths with tinsnips, blow torches, and precut silver and turquoise.

The group of objects illustrated here are called *ketohs*. The term refers to a wrist guard for archers worn on the arm that holds the bow so that the bowstring will not snap painfully against the archer's wrist. Prior to the introduction of silversmithing techniques *ketohs* were made of plain rawhide or, more rarely, fashioned from simple strips of copper or brass without ornament. During the 1880s the *ketoh* was introduced as a category of Navajo silverwork with a more ornamental than functional intent. Most, like several of those illustrated here, consist of a silver plate attached to a wrist band made of commercial saddle leather. The example on the far left of the group without settings of turquoise is the earliest of the group, dating to approximately 1890. Note the way the pattern on this piece was developed by repeated markings from a relatively narrow range of stamps. Later *ketohs* (to the right) display more elaborate patterns.

Northern Arizona.
Silver, turquoise, saddle leather.
Average length: 3 ½ in.
The Herbst Collection.

Pendant, Bracelet, and Ring

Sonwai (Hopi)

1991

apidary artists and silversmiths have been making jewelry in the Southwest for nearly 150 years, but it is the Navajo who are most strongly identified with the region's finest silver jewelry. Navajo Atsidi Sani is often credited with being the first to learn the basic techniques from a Mexican silversmith in the 1850s. After 1880, traders supplied artists with materials and supplies for the production of silver jewelry intended for sale to tourists. Jewelry artists from the Pueblos also contributed to the development of silversmithing and lapidary arts in the Southwest, with some Pueblos, like Zuni, establishing unique and extremely popular styles.

Through the early decades of the twentieth century, Native southwestern jewelry design had a distinctly "Indian" look: native turquoise was worked into designs that were soldered and bezeled, and the pieces were often decorated with geometric stamping that employed familiar "Indian" motifs. During the 1950s, Hopi jeweler Charles Loloma helped to change the course of Native southwestern jewelry design by introducing modern elements of style and a completely revolutionary design vocabulary. Loloma was trained as a painter by Hopi artist Fred Kabotie during the 1930s and studied ceramics at Alfred University in upstate New York. He was one of a small group who championed individuality in American Indian art, and this coterie of artists contributed to the founding of the influential Institute of American Indian Art in 1962, where Loloma was enlisted as a member of the faculty.

Like other artists of his generation, Loloma was faced with the task of redefining himself and his work as native Hopi within the context of a modern world. His life experience included service in the military during World War II, a friendship with Frank Lloyd Wright, and for-

mal studio training at an eastern university. His work integrated these very modern experiences with a Hopi's sense of his relationship to the land he called home. His jewelry combined different kinds of lustrous stone in settings loosely related to the mesas and landforms of Pueblo country. It was a distinctly modern expression of Loloma's sensibility as both a creative individual and a participant in a collective representation of what is "Indian" in the modern world.

Sisters Verma Nequatewa and Sherian Honhongva, known today collectively as Sonwai, served long apprentices with their uncle Loloma until health forced him to retire in 1989. They collaborated with him in the creation of most of his later work, and their jewelry carries on Loloma's vision today. The sisters began to use the name "Sonwai," which means "beautiful" in the Hopi language, when they first began to show their own work in 1989. This pendant, bracelet, and ring expand Loloma's geological metaphor for jewelry design, the juxtapositions of different semiprecious stones and their various textures suggesting the stratigraphy of weather-worn landscape. The colors and luster of fossil ivory, turquoise, and red coral capture something of the intense quality of Arizona light, the saturation of color that occurs when sunlight hits the native sandstone of the mesas and mountains.

Gold, set with fossilized ivory, jet, turquoise,
 coral, and seegilite.
Courtesy the Lovena Ohl Gallery, Scottsdale, Arizona.

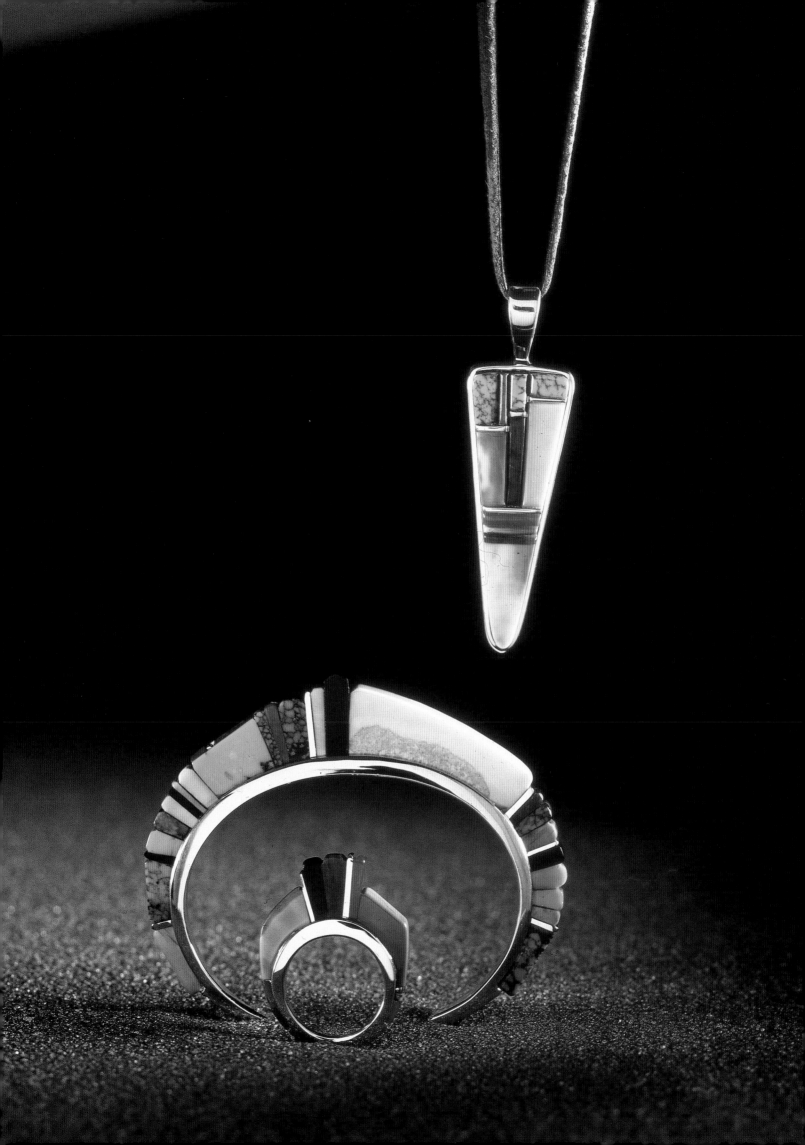

Burden Basket

Evelyn Henry (Apache)

1983

The Apache entered the Southwest with the Navajo sometime during the fifteenth century. They were an adaptive people who brought with them a rich culture, but they were also quick to learn from the new land and their new neighbors.

The Western Apache settled in the region that is now eastern Arizona, some bands favoring the forests of oak and pinion pine located in the cooler uplands to the north, others settling in the broad semi-arid valleys and mountains to the south. The term "Western Apache" actually refers to five distinct divisions—White Mountain Apache, Cibicue Apache, San Carlos Apache, Northern Tonto Apache, and Southern Tonto Apache— all of whom share many features of language and cultural practice. These divisions had little political relevance, the primary social unit being the modest-sized band composed of several related families or clans. The Western Apache were primarily a hunting and gathering people, although some families cultivated small fields of corn, beans, and squash. By far the most significant categories of foods prior to the modern era were wild game and a wide variety of wild plant foods, such as acorns, mescal, pinion nuts, mesquite beans, and juniper berries. The Western Apache lived close to the land and possessed an intimate knowledge of its gifts.

The burden basket has long been considered an essential utensil of daily life among the Western Apache. This particular type is made with two strong, U-shaped rods that strengthen the basket by forming a framework that crosses at the bottom and reinforces the corners. Long after buckets, gunny sacks, and other commercially made containers became available, Apache women continued to make burden baskets that were prized for their durability. Evelyn Henry made this one in the traditional style. Each corner is decorated with a fringe of buckskin bands. Variations in the twining technique create horizontal bands of contrasting textures that simultaneously strengthen the side walls. These baskets were difficult to make and were made to last.

Traditionally, burden baskets were used for a wide range of tasks, from collecting firewood to carrying belongings from camp to camp. They are still made and used today, partly because of their place in the Sunrise ceremony, a ritual that celebrates a girl's passage from childhood to adulthood. During part of the ceremony, the young woman runs a "race" around a course marked with burden baskets filled with foods intended as gifts to the girl's godmother. The gift of these traditional baskets is a way of acknowledging the responsibilities borne by the girl's godmother, who has helped raise her successfully into young womanhood. By running, the girl recognizes the need to remain supple and strong as an adult woman.

Wood (mulberry or salt cedar?, cottonwood, willow), buckskin, tin tinklers.
Courtesy School for American Research, Santa Fe, New Mexico.

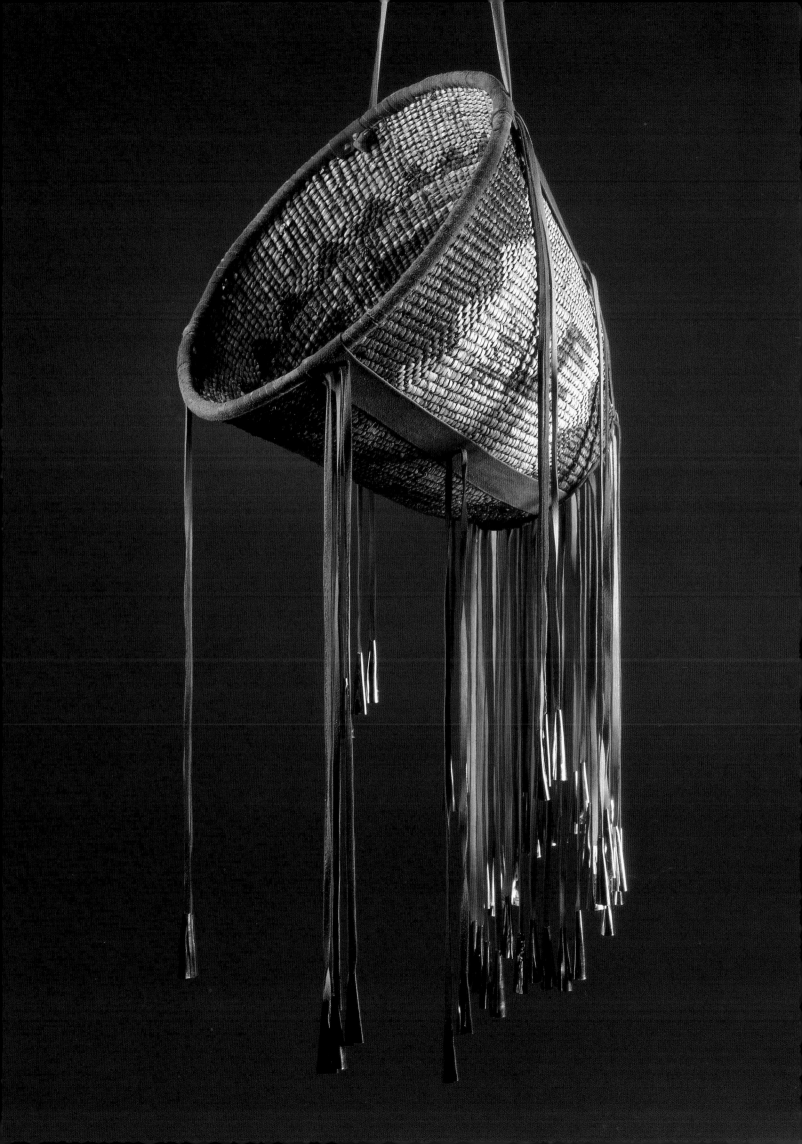

Basketry Jar

Chumash

Early 19th century

The Chumash were a large and wealthy ethnic group numbering nearly ten thousand at one time who lived along the coast and offshore islands near present-day Santa Barbara, California. Their large villages were composed of dome-shaped houses constructed of wooden scaffolding covered with neatly thatched grass. Individual sleeping compartments formed by interior partitions against the outer walls surrounded a central fireplace that was ventilated by a smoke hole in the middle of the roof. Villages numbered several hundred houses, with additional storehouses, a sweat house, a ceremonial enclosure for dances, a gaming area, and a cemetery.

Franciscans founded the mission San Luis Obispo in Chumash territory in 1772, within three years of the "sacred expedition" of summer 1769, during which Mexico established a permanent Spanish presence in California. Four more missions soon followed. The mission system was the principle means employed by the Spanish to establish control over Native Californian populations. The Spanish rounded up Chumash "neophytes" from the surrounding villages and housed them in mission barracks where they were forced into labor. Men and women were separated and often beaten into submission. Thousands died of disease. By the time the mission system was secularized in 1834, the once populous Chumash villages had all been abandoned; their former residents, vastly reduced in numbers, lived either at the mission or had escaped to the hills of the interior. By the mid-nineteenth century, the Chumash numbered just over one thousand.

Like many California peoples, Chumash women produced a wide variety of finely crafted baskets for many purposes, among them the gathering, processing, and storing of wild plant foods. The Chumash made no pottery, so basket jugs lined with asphalt functioned as water jars. Chumash housed in missions were encouraged to continue basket production, although production shifted to what the Chumash called *x'omho*, or trinket baskets, which were relatively small, globular baskets elaborately decorated, and designed to hold small, precious items. Spanish women commissioned these with the addition of lids as sewing baskets. The production of baskets for sale continued to be a mainstay of the Chumash cash economy throughout the nineteenth century. Sadly, due to the drastic reduction in the Chumash population and, consequently, the small number of Chumash basket makers, Chumash baskets are now exceedingly rare.

This finely made globular basket resembles the *x'omho* type but, with the added lid, served as a Spanish sewing basket. It is made with a coiling technique using whole *Juncus* stems for the foundation and split *Juncus* stems for coiling, sorted into natural golden brown and blonde, or dyed black by being buried in mud. The deceptively simple patterning is developed from alternating striped and checkered panels in vertical rows. Note how the size of each panel expands and contracts with the contour of the globular shape. This very early basket was probably made during the final years of the mission system; the Chumash artist combined ancient traditions of design and pattern with what were then innovative form and function.

Southern California.
Juncus stem.
Height: 15 3/4 in.
Peabody Museum of Archaeology and Ethnology,
 Harvard University, Cambridge, Massachusetts.

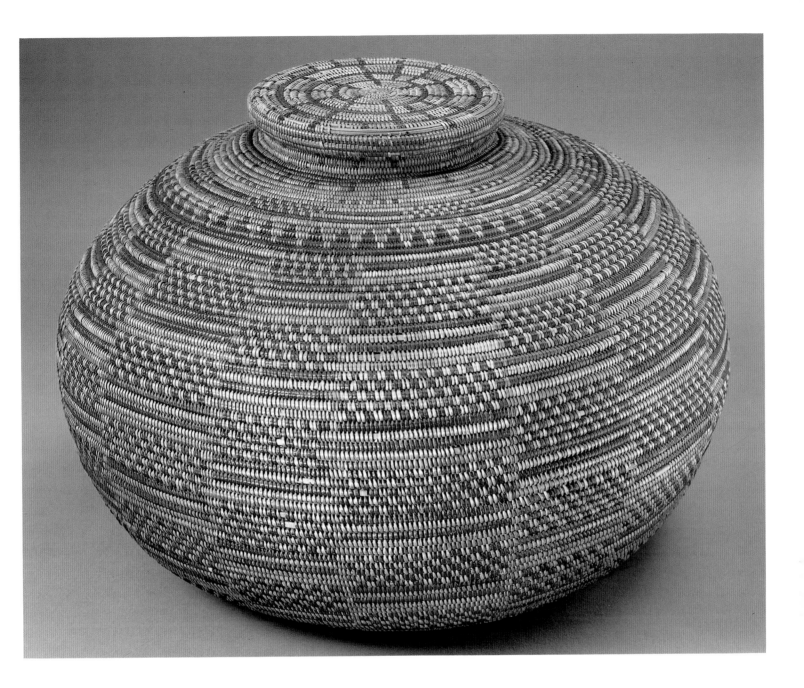

Feather Basket

Pomo

19th century

The term "Pomo" refers to seven different language groups, all related yet each as distinct from the other as English is from German. Speakers of the Pomo languages lived traditionally in the environs of the Russian River of central California. Their territory included the rocky Pacific coast and a low coastal range covered with redwood forests between the coast and the river, and extended east from the river all the way to Clear Lake, one of central California's largest bodies of fresh water.

The size of Pomo communities varied widely within this expansive territory, ranging from less than one hundred people to more than one thousand. Coastal villages were situated on the slope below the first range of hills back from the rocky, windswept shore. The redwood forest belt inland offered few resources to support village life and so was largely uninhabited save for the few small communities where the forest surrendered into glades and meadows. Redwoods provided timber for the construction of conical dwellings that were large enough in some cases to house as many as twelve people.

Baskets played an important role in the lives of most Native California peoples, and the Pomo were no exception. Baskets were employed in all areas of Pomo economy. They were used to trap fish, collect and transport plant foods, for storage, and even as cooking vessels and serving dishes. Pomo basket makers employed the techniques of coiling and twining in almost equal measure: durable storage and burden baskets were twined, while precious, more ornamental baskets were coiled. The most elaborately decorated baskets functioned literally as treasure and often marked life passages. The families of a bride and groom exchanged baskets decorated with shell beads and feathers. More baskets were given away as part of the wedding ceremony. Treasure baskets were also consumed in funeral pyres as an expression of esteem for the deceased. At the time of cremation, a large scaffold hung with baskets and other valuables was erected over the bundled remains of wealthy family members and set ablaze. Important families measured their wealth in terms of treasure baskets. These were most often coiled with minute stitches, measuring in some rare cases over forty stitches per inch. Applied decoration included small cut beads of white shell, pendants made from mother-of-pearl, and many different kinds of feathers: the red topknots of woodpeckers, the plumes of quails, the iridescent green feathers of male mallard ducks, and others taken from a variety of song birds.

This small basket woven in the shape of a shallow dish is a particularly precious variety of treasure basket. The bottom is completely covered with the minute red feathers of the acorn woodpecker, which were plucked individually from the prepared skin of the bird and inserted beneath each stitch as the basket was made. This *tapica*, or "red basket," is the oldest and most traditional form of Pomo feather basket, made with only red feathers. Later feather baskets of this type employed feathers of different colors to make mosaic patterns. Only the underside of this basket is decorated. When displayed, it hung suspended from a twine support strung with shell beads.

Central California Coast.
Sedge root, willow, feathers, shell, twine.
Southwest Museum, Los Angeles, California.

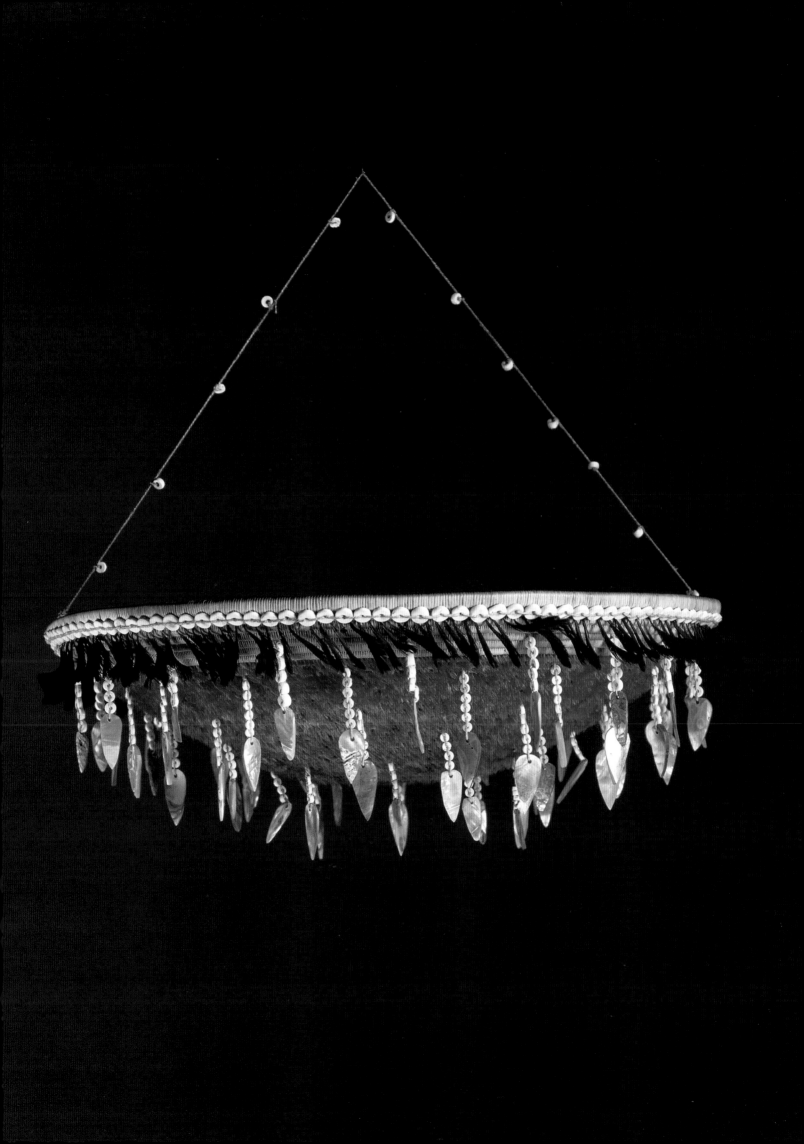

Dance Hat

Karok

19th century

The Karok lived along the Klamath River in northern California, close to the present-day Oregon border. They were located upstream from their neighbors, the Yurok, with whom they shared many aspects of cultural life but differed entirely in language. The term "Karok" means simply "upstream" and is not a term the Karok traditionally used to identify themselves. The Karok did not practice agriculture, but, rather, lived by harvesting salmon from the river and producing a nutritious flour from the pulverized meat of acorns, which they collected in great abundance. Traditionally, the Karok lived in semisubterranean houses of rough hewn planks grouped in small villages located along the river. Men spent much of their leisure time in larger, communal sweathouses, where they gathered with other men to converse and gamble, often returning to the homes of their wives and children only for meals.

Karok society valued industriousness and the wealth and prestige that resulted from it. Effort and achievement lead to leadership and prominence within the community. Extended families represented a kind of corporate group that pooled labor and supported the ambitions of male family heads, some families growing rich and powerful enough to virtually dominate community politics.

Male family heads displayed wealth as a means of expressing their social prominence on the occasion of important rituals. Wealth took the form of beautifully made baskets, headdresses decorated with the colorful feathers of birds, large obsidian blades, and other valuable possessions. The most important Karok ceremonies were referred to as "world-making" rites, and they were planned to coincide with the first harvest of acorns in the fall or the first salmon run of the spring. The dances were elaborate events staged over several days with many

out-of-town visitors in attendance to witness the display of wealth by the community's most prominent men. The public dances were preceded customarily by secret rites conducted privately by a priest within the confines of the communal sweat lodge. After ten days the public dances began, with important men from many different villages dancing in a line and displaying increasingly valuable regalia and possessions as the dances progressed. Excitement grew as the spectators admired each new valuable and wondered whether certain chiefs had brought particular items that would then be displayed.

This elaborate headdress made of deerskin and feathers was made and worn for a brush dance, which was a dance of lesser importance conducted by younger men, a kind of junior ceremony that helped to prepare the young men for participation in the far more elaborate world-renewal rites later in life. Ostensibly, the intent of the brush dance was to cure a sick child who had to be present at the ceremonies and for whom prayers were recited prior to the dancing. The young men danced for four days, with the final days reserved for the display of regalia and valuables. The decoration on this headdress is typical of the kinds of precious songbird feathers employed in the creation of Karok regalia. The red-shafted flicker feathers which crown the headdress are tipped with yellow breast feathers of the gold finch and are mounted on a cap of white deerskin, an extremely rare variety of hide.

Northern California.
Feathers, deerskin.
Height: 7 1/2 in.
Peabody Museum of Archaeology and Ethnology,
 Harvard University, Cambridge, Massachusetts.

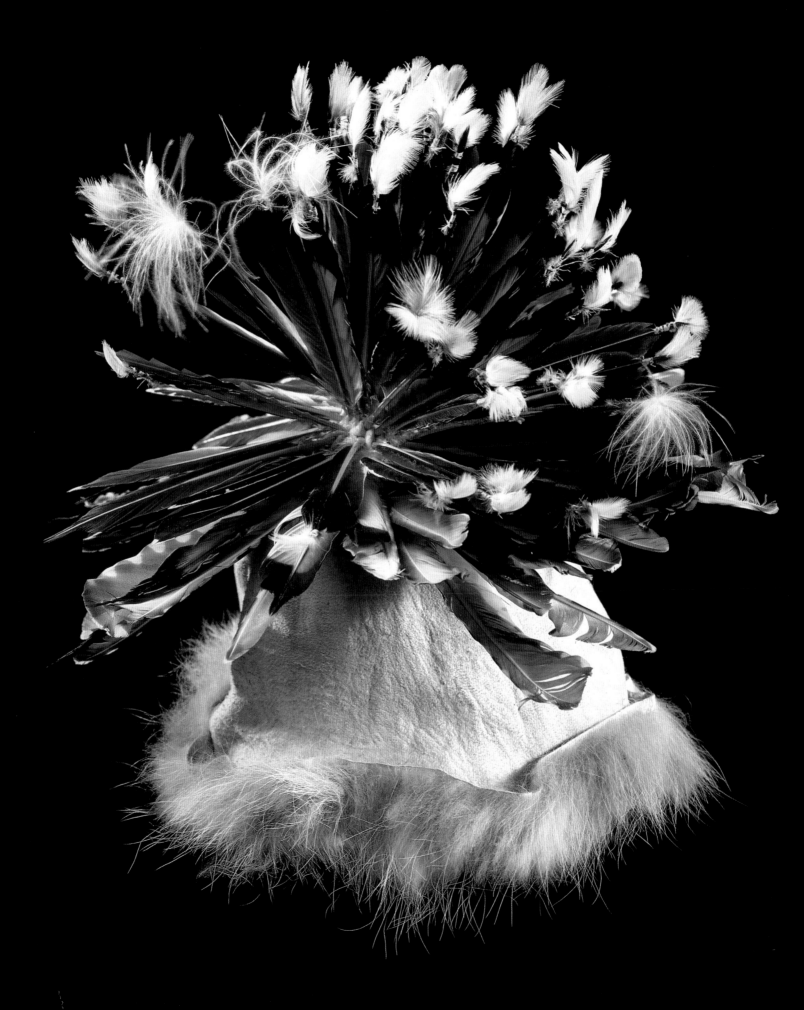

Basket Bowl

Kate McKinney (Maidu)

c. 1890

Little is known about Kate McKinney outside her community of Lake Almanor (formerly "Big Meadows") in the Mountain Maidu country of north-central California. She passed away sometime before World War II, having made baskets all through the first half of the twentieth century. Lake Almanor is located in one of the larger valleys high in the northern Sierra, above 4000 feet in elevation. The major Maidu settlement was built near "Big Spring," just off the valley floor, and was sheltered by a ridge of pine forest rising up behind it. Traditional Mountain Maidu people rarely traveled far from their home villages, and contacts with the outside world were very limited. The Mountain Maidu continue to live in this remote homeland, as they have for countless generations.

The term Maidu is often used to name three distinct, but linguistically related groups: the Mountain Maidu, the Konkow, or Northwestern Maidu, and the Nisenan, or Southern Maidu. Differences in traditional life between these divisions are tied closely to the environments they inhabit. Unlike the Mountain Maidu, the Nisenan and the Konkow live in and around the Sacramento Valley and established large villages on the valley floor. The Northern Maidu, in contrast, live in smaller villages in the Sierra foothills and traditionally frequented seasonal camps high in the mountains. All Maidu built small, domed houses covered with thatched grass, earth, or woven mats. Most villages included a larger dance lodge with a sunken floor and a roof supported by large wooden beams.

Like nearly all California groups, the Mountain Maidu produced a great variety of baskets employing both twined and coiled techniques. Maidu coiled baskets are highly coveted by present-day collectors, particularly the large, tightly sewn cooking bowls with their elegant, flaring side walls. The Maidu employed the "stone-boiling" method of cooking dishes such as stews by dropping heated stones into cooking baskets.

This small coiled basket was made as a fancy basket for sale. McKinney adopted the graceful bowl shape from the fancy baskets made popular by Washo and Pomo basket makers. The stitch count is unusually fine, which was an important factor when determining the basket's value in the outside world. Maidu basket designs were composed traditionally of blonde and red materials: willow or peeled redbud shoots for the blonde color, and unpeeled redbud with its distinctively colored bark for the nearly purple red. Sometime shortly after 1900, Maidu women like McKinney began to employ the root of maidenhair fern for black, as in the pattern seen here.

This graceful basket presents an appealing figural design using the images of large birds with wings spread. Black birds rise toward the upper rim of the bowl, while a larger red bird, placed lower in the design, holds a serpent in its talons. The image of the Thunderbird attacking a horned serpent is traditional for the eastern and northern Pacific tribes but foreign to the Maidu. McKinney borrowed the concept for the imagery in an attempt to anticipate the interests of her buying public. Such figural designs proved very popular among collectors of Indian baskets, whose numbers swelled appreciably during the first decades of the twentieth century.

Sierra Nevada, central California.
Redbud, willow, bracken fern root.
Diameter: 13 1/2 in.
Janis and William Wetsman Collection.

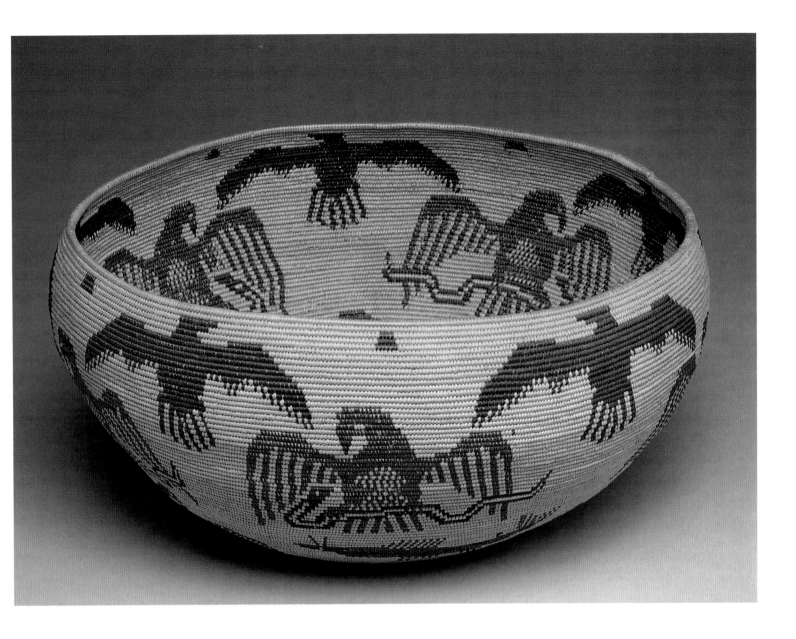

Coiled Basket

Carrie Bethel (Mono Lake Paiute)

1930s

The Mono Lake Paiute live in the Mono Lake Basin, a high shoulder (6,400 feet above sea level) of the Sierra Nevada, which rises abruptly to the west. Traditionally, the people harvested the abundant water fowl that frequented salty Mono Lake, hunted animals of the surrounding pine forests, and gathered dozens of different plant foods from the plentiful land. Like many California and Great Basin peoples, the Mono Lake Paiute required many different types of baskets to fit their lifestyle. Baskets were used for collecting plant foods, processing plant foods in various ways, cooking, storage, and many other tasks. People also took great pride in their baskets, the number of finely made baskets belonging to an individual or family considered a measure of wealth and social standing.

The Mono Lake Paiute traded regularly with the neighboring Miwok, who lived in the region that became Yosemite National Park. When visitors to the park began to look for baskets to buy as souvenirs of their visits, both Paiute and Miwok women were quick to adapt their skills to satisfy the new market. Carrie Bethel was one of several accomplished Paiute basket weavers who worked in Yosemite National Park during the first decades of the twentieth century. She made baskets for sale to park visitors as well as for several commercial vendors of Indian baskets throughout the country. Her award-winning baskets were widely admired, and she sold many of them. The technical excellence of Bethel's work rivals her better known contemporaries like Washo basket maker Louisa Keyser (Datsolalee) or Yurok Elizabeth Hickox, who, like Bethel, were among the many women who responded to the enthusiastic white market for finely made baskets during the early decades of this century.

This magnificent example of basketry art is the largest ever produced by the artist: it took her four winters to complete. It was made with a difficult coiling technique in which the structural and decorative aspects of the basket were executed simultaneously. The design was not applied, but was, rather, part of the construction and therefore had to be worked out as the basket took shape. The busy, complex design is typical of the kind of innovative work that was so attractive to buyers. The best baskets, like this one, combined fastidious workmanship with absolute mastery over the integration of volumetric shape and surface patterning. Despite all the different component parts, each element of the pattern is evenly arranged in perfect symmetry around the gracefully swelling form.

Yosemite Valley, central California.
Sedge root, redbud, bracken fern root, willow.
Diameter: 32 1/4 in.
Yosemite National Park Collection.

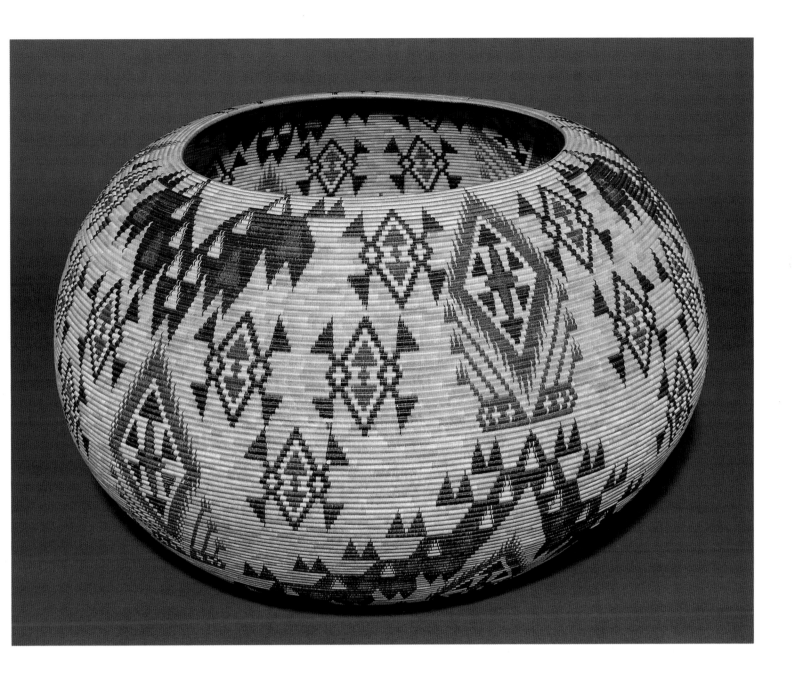

Ishi and Companion at Iamin Mool

Frank Day (Maidu)

Early 20th century

Frank Day was born in 1902 at Berry Creek, California. At that time the Maidu as a people were making the difficult adjustment to the twentieth century. The population had been reduced by disease and other factors from more than four thousand to just over one thousand. A great deal of traditional knowledge was in danger of being lost. Day was educated to become a minister, but pursued painting as a way of exploring and preserving the oral traditions and ceremonies of Maidu culture. He learned much about Maidu tradition from his grandfather and was eagerly sought out by young anthropologists as an authority on the subject.

Most of Frank Day's pictures represent traditional religious practices or illustrate episodes of Maidu folk tales and myths. Like Ernest Spybuck and Carl Sweezy, Day adopted a kind of ethnographic self-consciousness about his traditional culture, which he experienced largely through the memories of his elders. The work of all three artists was conceived to preserve a record of tribal knowledge and a way of life they feared was in danger of vanishing forever. To fulfill this task, Day developed a very direct, pictorial, narrative style of painting. He wanted to show his audience the unique attributes of his culture with as much clarity as possible.

This picture is fairly unique among Frank Day's works because it is drawn from personal experience rather than from traditional life as recounted by elders. Even so, Day conveys in this picture a sense of the mysterious and miraculous that gives the scene a kind of mythic stature. In 1911, the last surviving Yahi man, named Ishi, was "discovered" by anthropologists from the University of California Museum of Anthropology. Ishi had lived in the southern Cascade Mountains since his birth in about

1860. Frank Day recalled walking in the mountains with his father one day and seeing Ishi with a companion at a distance before his "discovery." Apparently, Ishi was performing a rite of healing using sacred stones and crystals. Day painted his memory of the encounter many years after the event.

The picture is typical of Day's manner of representation. The figures are solidly painted within a simple landscape setting illuminated by bright and flat California light. The injured patient lies on his back while Ishi kneels over him performing the rites of healing. In the manner of "magic realism," Day shows us the healing energy that flows from the rising sun, to a crystal set on the ground, and through a basketry bowl filled with liquid that is dispersed as healing power across the patient's wound. Ishi himself stares directly at the viewer; it is as if he wants to tell us the significance of the ritual. The picture is at once a recollection of Frank Day's experience and a pictorial demonstration of Yahi rites of healing. Day was always a teacher and a student whose painting was intended to record and to instruct.

Oil on canvas.
24 × 35 7/8 in.
Collection of Mr. and Mrs. H.C. Puffer.

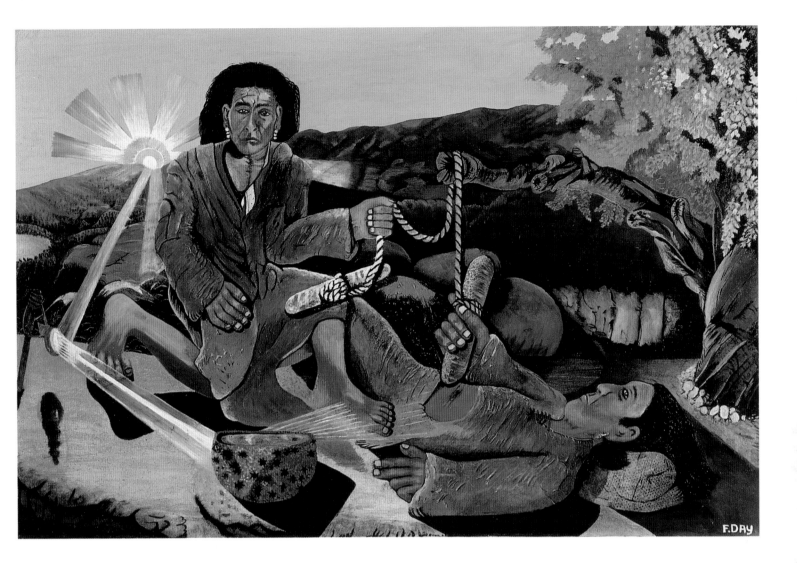

Seated Human-Figure Bowl

Marpole culture

350 B.C.–A.D. 200

The region of southern British Columbia and Washington State surrounding the Straits of Georgia has been home to Coast Salish people for thousands of years. The key to cultural life is a natural cycle much older than the earliest human habitation: the annual spawning runs of Pacific salmon. Beginning in late winter and early spring, chinooks and cohoes were caught offshore by trolling prior to their late spring runs up the Fraser River. In July, thousands of sockeye and pink salmon were caught in a single day using offshore reef nets anchored to the bottom. As the salmon entered the mouth of the Fraser, fishermen harvested them from canoes with trawl nets and dip nets. Salmon caught in the summer were dried and preserved and sustained the Coast Salish throughout the following winter.

This relatively stable economy was first developed among the earliest inhabitants some 5,000 years ago. Archaeologists use the term "Marpole culture" to describe the episode of the "middle period" of Coast Salish development in the Straits of Georgia region between 400 B.C. and A.D. 400, which was characterized by a rich material culture including objects carved in stone and bone with images of human beings and animals. Stone woodworking tools recovered from Marpole sites testify to a tradition of wood sculpture as well, although few Marpole objects made of wood have survived to the present.

Among the most impressive and enigmatic categories of objects linked to Marpole culture are soapstone (steatite) bowls carved in the form of seated human figures that often appear to cradle the bowls in their arms. This is a particularly elaborate example among the more than fifty that have been found. The figure leans backward with the oval bowl gripped between its arms and legs. The massive head seems to wear a mask with a hooked nose

resembling a bird's beak, its mouth slightly parted and its oversized eyes shadowed by overhanging brows. A bulbous protrusion that stands upright on the back of its head may represent a topknot of hair or part of a headdress. The forepart of the bowl itself is carved with the glowering head of an indefinite figure with vaguely amphibian features. Remarkably, this configuration of a human figure who grips a bowl that then becomes an animal form anticipates carvings made by Northwest Coast artists more than a thousand years later. Clearly this sculptural idea was charged with deep and lasting symbolic meaning..

The symbolism of the carving is not easy to interpret. The bowl apparently functioned as a mortar for grinding tobacco, which was a sacred substance employed by a religious healer known as a shaman. Tubular smoking pipes of steatite carved in a similar manner have also been recovered from Marpole sites; in one instance both a mortar (like this one) and a pipe were found together. If in fact the bowl and pipe were religious objects, then the figures carved on the bowl may represent the spiritual helpers of the shaman who are fed by the holy man in thanks for their assistance. Although the concept for the bowl survived into later Coast Salish history, this kind of tobacco ritualism did not, and therefore is not remembered among the Coast Salish people. Similar kinds of tobacco ritualism and utensils were employed by shamans of neighboring California, however, providing clues for the interpretation of this Marpole culture object.

Washington State.
Stone (steatite).
Length: 8 5/8 in.
National Museum of the American Indian, Smithsonian Institution, New York.

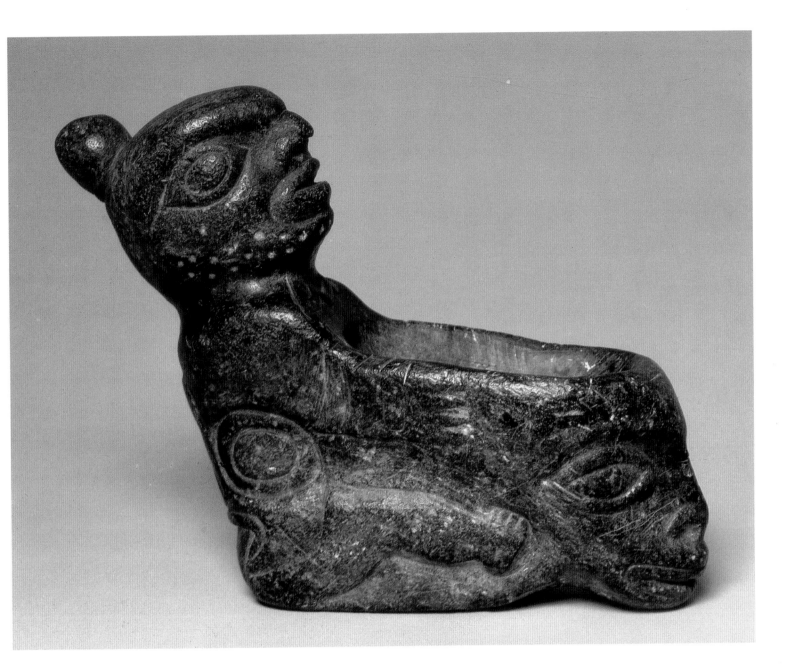

Oil Dish

Quinault

19th century

The Quinault belong to a large group of Salish language speakers who have lived traditionally in what is now Oregon, Washington State, and southern British Columbia. Coast Salish villages were always situated strategically to harvest spawning fish from the nearest productive salmon stream. The Quinault lived along the Quinault River in western Washington State, where their reservation is still located. Although salmon was the mainstay of the Quinault's diet, elk and other game could be hunted in the hills and forests that rose on either side of the river. Some men living in coastal villages even took to the open sea to hunt whales, a dangerous but prestigious activity.

The families of Quinault villages were ranked in relation to one another, village leaders and nobles coming from the highest ranking families. Beautiful objects like this elegant oil dish testified to high-born status. Carefully carved in the form of a four-legged creature with a deer's head and a long neck framed with scalloped spines in front and back, this dish was most certainly owned by a wealthy and powerful family who counted it among their other treasured possessions. The white glass beads inlaid for the eyes and running down the neck around the rim further enliven the already detailed carving. During feasts, dried fish was consumed by dipping morsels into bowls like this that were filled with oil rendered from seal blubber.

The bowl was probably intended to represent some kind of other-worldly creature, perhaps a sea monster. A familiar story among the Quinault recounts how a man fishing for salmon one day on a weir saw something swimming in the water. The creature's head looked like a deer, but when the people looked closely they saw that it was a *skuku'um*, a water spirit, with a snakelike body and short, stumpy legs. This particular being was obviously dangerous, since everyone who gazed upon it soon died. Only an old woman and her child survived, because, in her wisdom, she knew the creature posed a great danger. Quinault tradition holds that sea monsters, although dangerous, can also offer wealth and valuables. A young man swimming in a lake once caught a small *skuku'um* with his hands, dragged it from the shore, and placed it beneath his house. Later, when he came out to show his find to his family, all that remained in its place was a treasure of dentalium shells.

These contrasting stories about the attributes of *skuku'um* reveal much about Salish attitudes toward power and privilege. The mysterious and spiritually charged powers that *skuku'um* represent are dangerous to those who are unworthy or unprepared, and yet offer untold riches and success to others who are strong enough or entitled to receive them. The image of the sea monster carved on this fine heirloom bowl testifies to the spiritual strength of the family who owned it, a family that had frequently received powerful and potentially dangerous blessings from mysterious beings and who continued to enjoy the wealth and privileges that stemmed from them.

Western Washington State.
Wood (alder or yew), glass beads.
Length: 12 in.
Whitman College Collection.

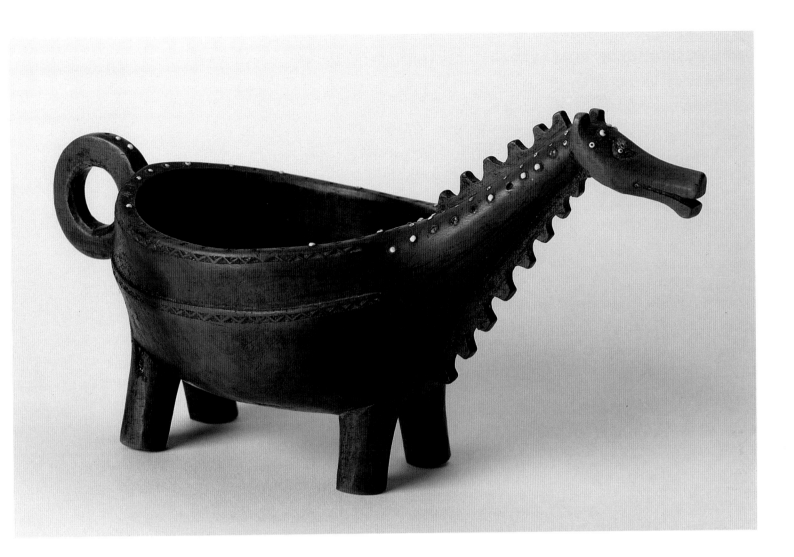

Hamatsa Crooked Beak Mask

Willie Seaweed (Kwakiutl/Nakwaxda'xw)

1940s

The Kwakiutl live along the Straits of Georgia on the southern coast of British Columbia. Their traditional livelihood depended primarily upon abundant harvests of salmon and smeltlike candle fish, and they divided their time between spring and summer fishing camps and large seaside winter villages. The winter has always been the ceremonial season, the time for planning and hosting large feasts called potlatches and staging impressive ceremonies. This mask represents a cannibal bird known as the Crooked Beak monster, which appears as part of the cannibal dance, the most powerful supernatural masquerade of the Kwakiutl.

According to the mythic narrative of the cannibal dance, the Crooked Beak is one of four monstrous beings who live at the north end of the world and crave human flesh. During the winter season, they come south to the Kwakiutl villages to capture young men of noble families and transform them into cannibals. At large intervillage feasts and "give-aways" known as potlatches, the chiefly host may stage a reenactment of the cannibal monster myth with his own son portraying the victim and fellow clansmen impersonating the dreaded cannibal monsters by wearing frightful masks like the one seen here.

The cannibal dance is performed over a period of several days when guests from other villages have assembled for a potlatch. Late in the first evening, after everyone has been assembled and fed in the host's massive wooden house, the guests hear strange and eerie whistles that announce the approach of the cannibal monsters. Suddenly, the chief's son vanishes, having been kidnapped by the cannibals. In reality, special dance assistants have taken him to the forest where they tell him how to perform the last act of the drama. When the chief's son returns to the village he behaves as if he has become a cannibal himself, and he must be restrained from attacking others. He is seen devouring what appears to be a corpse, or biting his attendants. The culminating dramatic moment of the cannibal dance comes the last evening of the potlatch, when the elder men of the village must cure the young man of his hunger for flesh. After dancing to cannibal songs, he is purged of cannibal influence through the ritual acts of the elders. Four cannibal monsters, all monstrous birds with enormous beaks impersonated by men in masks, then emerge from the back of the house and dance around its central fire pit. The Crooked Beak dancer wears the mask tilted upward, pausing occasionally while dancing to snap its beak hungrily as a sign of its voraciousness.

This particular mask is an especially flamboyant representation of the Crooked Beak made by one of the Kwakiutl's most famous and accomplished carvers, Willie Seaweed. The Crooked Beak monster is supposed to have a broad, gaping mouth, large red nostrils, and a hooked crest above the upper jaw. The gracefully spiraling forms above and below the jaws here are unique Seaweed inventions, and the exaggerated style of carving shows Seaweed's creativity and skill at their best. The colorful, dynamic representation of this monster was intended to be experienced within the dramatic context of a danced performance, but even as static sculpture apart from the drama it is powerful and haunting.

Kingcome Inlet, British Columbia.
Wood, cedar bark, paint.
Length: 37 in.
Courtesy of the Royal British Columbia Museum.

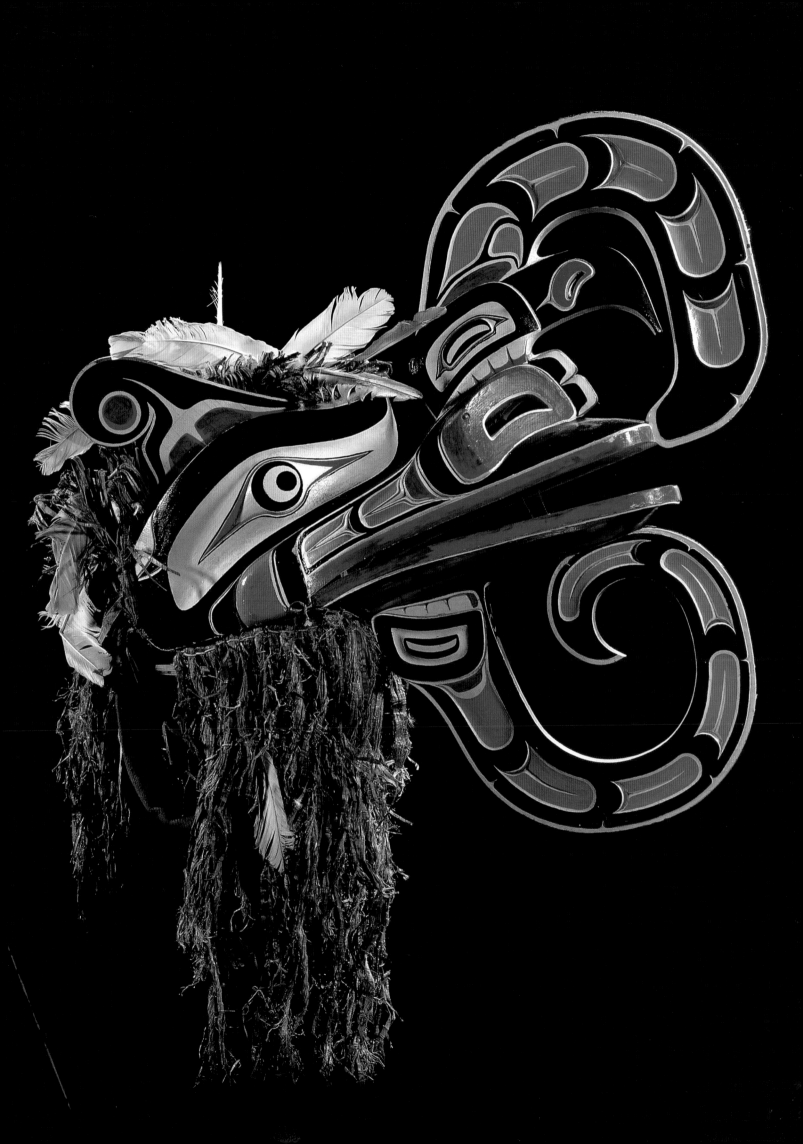

Sun Mask

Bella Coola

19th century

The Bella Coola are a Salish-speaking people who once lived in forty-five villages located along the Bella Coola, Deans, and Kimsquit rivers, and the Burke and Dean channels that lead to the Pacific. The terrain is rugged and heavily forested, with mountains that rise abruptly to the east, and is riddled with a complicated tangle of waterways and channels that characterize much of the British Columbia coast. The influx of deadly epidemics reduced the numbers of Bella Coola considerably, and now most Bella Coola speakers live in one village, Bella Coola, at the mouth of the Bella Coola River.

Like their Northwest Coast neighbors, the Kwakiutl, the Bella Coola staged elaborate masked rituals during the winter months to accompany feasts and potlatches. The *kusiut* society, whose membership was determined by ancestral right, organized masquerades, keeping secret the means by which they impersonated powerful supernatural beings. Many of the *kusiut* masquerades dramatized the mythic narratives of Ahlquntam, the most important of the supernatural creatures recognized by the Bella Coola. Ahlquntam was the creator of all men and animals, the master of fate, and the leader of all supernatural beings. He and his counselors decided who would be born among human beings, who would die, and who would be initiated to perform *kusiut* dances. He was often impersonated at *kusiut* performances, appearing with a large, humanlike mask, and would watch impassively from behind the fire, occasionally pronouncing in a powerful voice, "Mortals! See me! I am Ahlquntam!"

This mask represents the sun, which Ahlquntam used as his canoe and which he guided across the sky while wearing a cloak lined with salmon. According to the myth, when Ahlquntam reversed his cloak, the rivers would run

abundant with salmon. During the *kusiut* ceremonies, the mask was raised against the rear wall of the dance house and traveled across the ceiling, simulating the journey of the sun across the sky. This was accomplished with strings and other mechanical contrivances.

The three-dimensional face of the sun in the center of this mask is framed by two ravenlike birds, a killer whale, and wings painted on the sun disk frame. This single piece illustrates the best of Bella Coola carving and painting. The face in the center, which may represent Ahlquntam being borne in his spirit canoe of the sun, is conceived in broad, bold volumes reinforced by surface painting that emphasizes the cheekbones and eye sockets and frames the strong mouth and chin. The eagles and killer whale that surround the face are painted in a dynamic, free-hand style that plays creatively with the so-called formline conventions of Northwest Coast art. Each being is composed of the ovoid and split-U elements typical of Northwest Coast graphic design combined with a more pictorial manner of representation.

Central British Columbia.
Wood, paint.
Diameter: 42 3/4 in.
The Seattle Art Museum, gift of John Hauberg.

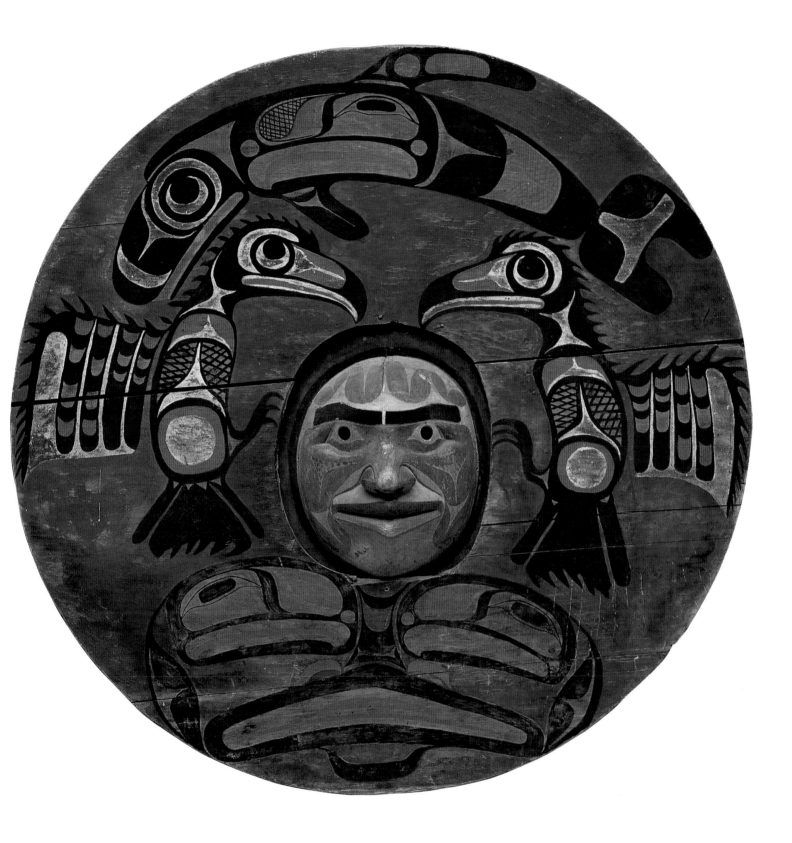

Bent-Corner Chest

Bella Bella

19th century

The Bella Bella are a northern Kwakiutl village people who live along some of the innumerable bays and inlets of central British Columbia of the North Pacific Coast. They border the Tsimshian people, who live to the north, and the Bella Coola to the south. The inlet village locations were well protected from the open sea, so that Bella Bella communities became a frequent stop for American and British maritime traders early in the nineteenth century. By mid-century, the Bella Bella had established themselves as middlemen in a flourishing trade that brought great wealth to their villages. This fact may have contributed to the growth of Bella Bella arts as a trade commodity in the late 1800s.

Bella Bella artists became widely known for the quality of their bent-wood boxes, chests, horn spooons, wooden dishes, and other carved objects. Bella Bella painting was so distinctive that modern scholars are able to identify objects in museum collections as made by Bella Bella artists, even though they were collected some distance away in Haida, Tsimshian, and Kwakiutl villages. This chest represents the highest level of Bella Bella craftsmanship, with its exquisitely chiseled designs on the front and back and painted panels on the shorter sides.

The principles of Northwest Coast graphic representation were developed into a codified and conservative system known as "formline design," which employed a narrow range of standardized elements (ovoids and split-U's, for example), to create highly stylized images of different animals. Bella Bella boxes are known for their thin and graceful formline painting, which is particularly evident here in the carefully proportioned design painted on the narrow side of the chest, as well as the open quality created by the intervening spaces on the front, painted blue, within the formline composition.

This massive cedar chest stored important regalia and other possessions and was made by a master artist who was fully conversant with the intricacies of formline design conventions. The sides are made of a single cedar plank, bent, or "kerfed," at three corners and stitched together with cedar root at the fourth. The base is also secured to the sides with cedar root laces. The lid is carved with an inset ridge so that it fits snugly. The two long sides of the chest are carved in shallow relief and painted with a generalized animal design, conceived so that it spreads out over the entire oblong face of the chest. The head of the animal, outlined with a black formline, fills the upper portion of the design. Miniature, frontal faces function in the design as eyes, and four ovoid elements, one placed at each corner, represent the joints of the creature's hips and shoulders. Elements of the body, composed of repeating and standardized elements, fit into the panels below and on either side of the head. Note the delicate red hands with blue ovoids in the palms located on either side of the central lower panel that seem to support the composition.

Milbanke Sound, British Columbia.
Wood (cedar), paint.
Length: 35 ¾ in.
The Seattle Art Museum, gift of John Hauberg.

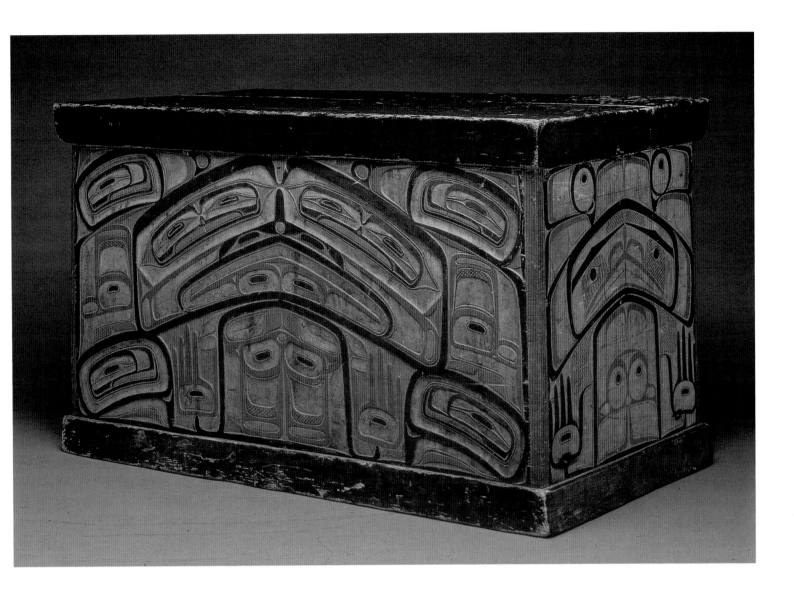

Female Figure

Haida

Mid-19th century

The Queen Charlotte Islands stand some ninety miles off the rugged coast of British Columbia. They are home to the Haida, who at one time commanded the surrounding seas with large ocean-going canoes, raiding mainland villages with near impunity. The massive winter houses of Haida chiefs and the great memorial poles that represented clan histories and stories of origin were the product of long-standing woodworking traditions. Artists received training from elder master-carvers. Accomplished carvers became widely known and were sought out for commissions from distant communities but only rarely supported themselves exclusively by carving.

The first several decades of the nineteenth century witnessed a dramatic growth in wealth among Haida communities. Whalers of the North Pacific fleet often put in to Haida villages for provisioning, and the Hudson's Bay Company established trading posts on the Queen Charlottes in search of the pelts of the plentiful sea otter. In addition to the opportunities of the fur trade, carvers found lucrative markets for small sculptures sold to the frequent visitors. Although many such carvings were produced in argillite, a black slate native to the Queen Charlottes, similar styles of miniature sculpture were also produced in wood, like this small female figure. During the period between approximately 1830 and 1860, carvers experimented with European-derived subjects and conventions of representation in an effort to create sculpture that would appeal to outside buyers. Fanciful renditions of ships, European-style architecture, and even portraits of ship captains owe little to traditional Haida art beyond the rigorous traditions of carving that contributed to the development of the artist's hand and eye.

This realistic carving of an attractive Haida woman in European-American dress was probably intended to serve as a memento of the sexual opportunities available to those who visited the port of call of the Queen Charlotte Islands during the mid-nineteenth century. Prostitution of Haida women provided a source of wealth with no disgrace. In fact, some accounts suggest that women who became wealthy as prostitutes were highly honored. Haida carvers were quick to respond to the interest of potential buyers, and there is a small, but significant group of carvings like this one that seem to represent attractive Haida prostitutes, well-dressed in European-style clothing, all holding the handbags which symbolized the wealth garnered through their vocation.

The figure stands confidently, hands on hips, a handbag dangling from one hand. Despite her European-style clothing, she is barefoot. Her lower lip is braced with a small labret, an ornament that European-American men found distasteful but was considered a mark of beauty and privilege among the traditional Haida. Her tresses made of fiber, perhaps real human hair, are an unusual detail. This carving is a small masterpiece of adaptive aesthetic, since the carver, trained in traditional conventions of Haida art, has so completely mastered the European representational conventions of pose and drapery. Only the masklike face with its characteristically Haida-style of eyebrows in relief and the delicately rendered eyes betray the artist's traditional training.

Queen Charlotte Islands. British Columbia.
Wood, yarn. Height: 11 in.
The Thaw Collection, Fenimore House Museum,
 Cooperstown, New York.

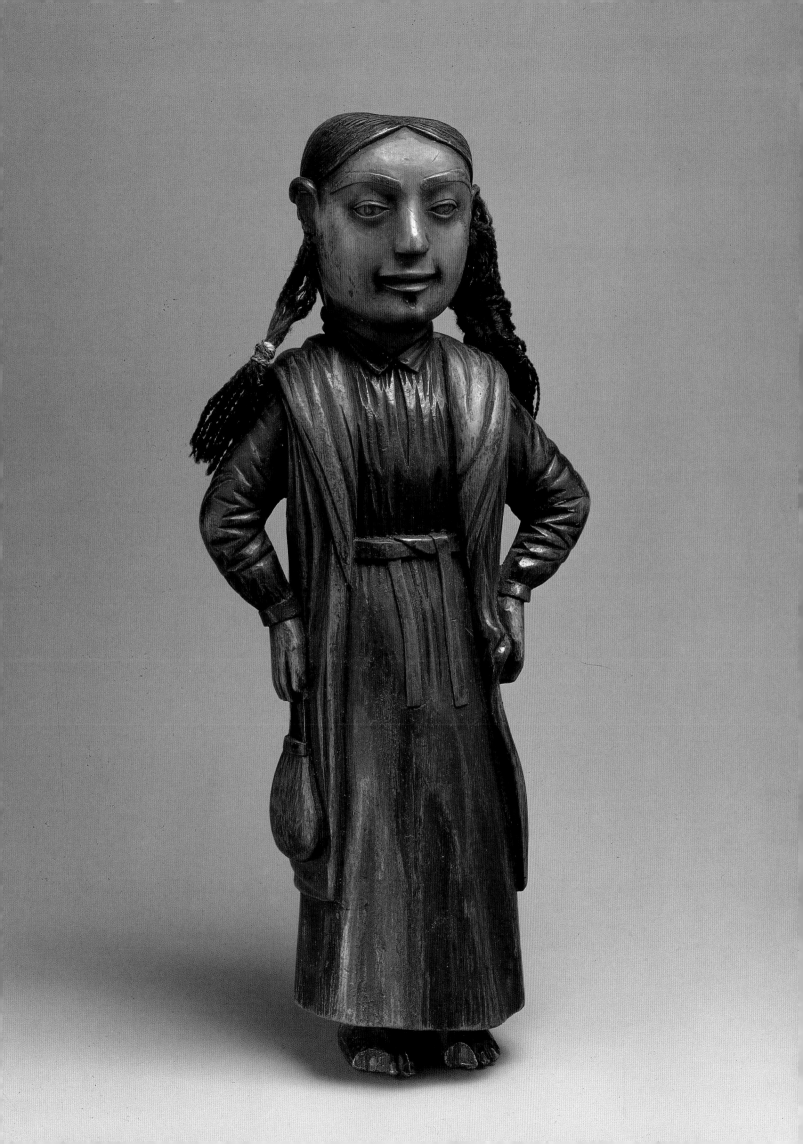

Woman's Parka

Caribou Inuit (Padlimuit)

1938

The Padlimuit live, as do other central Arctic Inuits, on the west shore of Hudson's Bay. During the summer thaw, the community would move inland to hunt migrating caribou, and during the winter hunters would venture out onto the pack ice to hunt sea mammals. Survival in the demanding Arctic environment required an intimate knowledge of and close relationship with nature. People identified with the animals they hunted and upon which they depended. Animals were thanked, ritually, for allowing themselves to be hunted and for giving up their bodies as food. If the quarry was treated with respect, it was believed that other members of the same species would allow themselves to be taken.

The caribou hide parkas made by central Inuit women mimic in their cut and fit the appearance of a caribou, thereby merging the identity of the Inuit hunter with that of his principle quarry. This is a woman's parka, called a *quilittaq*. It is distinguished from a man's parka by the large hood which functions as a pouch to carry infants. The parka design allows a young mother to transport her child on her back, and to position the child at her breasts to nurse so that both she and the child are not exposed to the punishing cold. Imagine a woman wearing it, her child held securely on her back with its head above her shoulder, their two faces peering out side-by-side from within the hood.

The elaborate decoration visible on this parka resulted in part from the proximity of Padlimuit communities to Hudson's Bay trading posts, where glass beads and colored cloth could be procured in abundance. The Padlimuit Inuit hunted fur seals for their pelts, which they traded for metal tools and other useful items. Ornamental materials such as cloth and glass beads intended for the decoration of garments like this parka were highly desirable as trade goods. Using trade materials for clothing ornament was not simply an expression of vanity: it symbolized wealth, success, and the abilities of the Inuit family to hunt successfully, to prepare pelts, conduct trade wisely, and to make and decorate the things, like garments, that were required for living.

The parka is a strong expression of several, interrelated cultural values, including the spiritual regard for the caribou, whose hide it employs and whose form it emulates. The addition of trade materials for ornament illustrates how the Inuit integrated participation in the fur trade with a traditional world view. Padlimuit women readily substituted the colorful glass beads for the customary decoration of cut and painted hide. The decoration on the parka derives from the traditional practice of decorating the body for aesthetic and symbolic purposes. Beaded fringe hangs from each shoulder, for instance, which is one of the joints of the body on which women were traditionally tattooed.

Eskimo Point, Hudson's Bay, Northwest Territories, Canada.
Caribou fur, wool cloth, glass beads, caribou hide, caribou teeth.
Length: 48 in.
Royal Ontario Museum, Toronto.

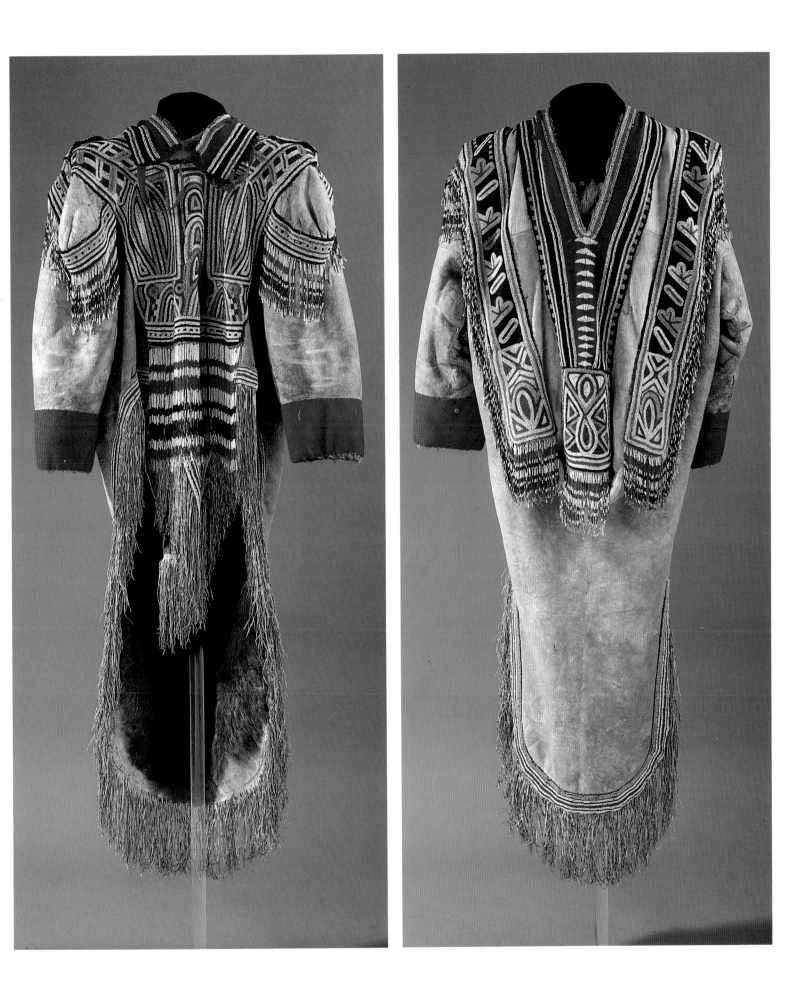

Indian Horse

Jaune Quick-to-See Smith (Flathead/Salish)

1992

Jaune Quick-to-See Smith was born on the Flathead Reservation and earned a Master of Fine Arts degree at the University of New Mexico, Albuquerque. She describes her studio fine arts training as rooted in a tradition that is white, Eurocentric, and male. Although her academic training did help her to resolve issues of technique and surface, it had little relevance to what she really wanted to say in her paintings.

The earth, its creatures, and the environment have always been of primary importance in Smith's work, whether on canvas or paper. Her paintings of the last twenty years have often resulted from activist concerns, but her poetic, metaphorical manner of working is rarely polemical. Images of moths, butterflies, and sandhill cranes that appear in her paintings of the late 1980s stemmed from her concern for their diminishing populations. An ambitious series of works inspired by these words of Chief Seattle's 1854 speech to the white citizens of Washington State was intended as a strong environmentalist message: "Every part of this country is sacred to my people. Every hillside, every valley, every plain and grove has been hallowed by some fond memory or some sad experience of my tribe. . . . The very dust under your feet responds more lovingly to our footsteps than to yours, because it is the ashes of our ancestors."

Indian Horse would seem to be an autobiographical work. Images of horses frequently appear in Smith's paintings, and they seem to be a kind of metaphor for herself. Since her father ranched and traded in horses, they have always been part of her life and her perceptions of them are steeped in the memories of her childhood. Horses have also come to symbolize Smith's self-avowed nomadic way of life. Her own horse, Cheyenne, is a constant companion and has often stood in for her in early landscape works, inhabiting a field as an expression of Smith's link to the environment, or, as in one painting, standing in her studio door.

In this work, the broad outlines of the Indian horse fill the dimensions of the oblong canvas. The painterly surfaces in yellow and red both inside and outside the figure pun her horse Cheyenne's markings as a Pinto, a "paint." Printed ephemera and illustrations related to her homeland, the Flathead (Salish) Reservation of Montana, are scattered throughout the composition. An image of Chief Joseph, the most famous Indian leader of the northwest tribes, is placed in the upper center. Barely visible at the horse's shoulder and near one foreleg are line drawings of "Ken Plenty Horses" and "Barbie Plenty Horses," a fictional Salish family excerpted from another Smith piece, *Paper Dolls for a Post-Columbian World*. A Salish vest beaded with floral patterns can be seen below the horse's head, and the cover of a museum exhibition catalogue, *Salish Indian Art*, is located beneath the horse's belly. A powwow poster, family photographs, advertising (Ranchera Bartlett Pears), and newspaper stories ("Indian History Lost in the Centennial") all emerge through the painted surfaces of the picture. The image of the horse locates Smith herself amidst this crowded and often confusing cultural landscape. The combination of iconic images on painterly surfaces with found images and texts characterizes several of Smith's more ambitious pieces of the early 1990s.

Oil, mixed media, collage on canvas.
66 × 96 in.
Collection of the artist.

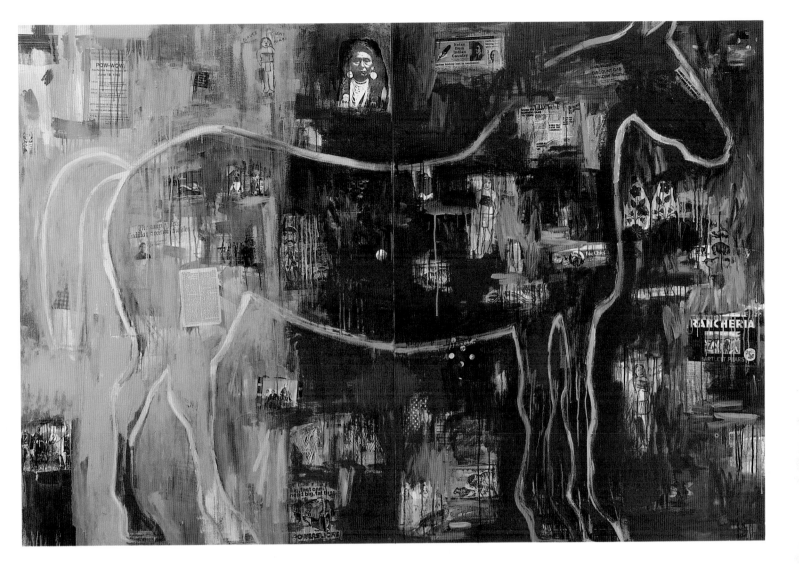

The Things Colonial Angels Witness

Gail Tremblay (Onondaga and Micmac)

1992

Gail Tremblay grew up in Buffalo, New York, and pursued university training in drama, creative writing, and studio arts. She is known best today as a fiber artist and teacher. Her work has been featured in several nationally prominent exhibitions over the last few years, including the prestigious Heard Museum Biennial (1992), *The Submuloc Show/Columbus Woes*, curated by Jaune Quick-to-See Smith, and the *Seventh Generation* exhibition, where this particular work was first shown.

Tremblay conceived of *The Things Colonial Angels Witness* as a reflection on the Columbus Quincentennial. In a statement prepared for the catalogue of the *Seventh Generation* exhibit, Tremblay began by pointing out that the survival of Native American people today testifies to the principle that the earth, with its fathomless cycles of being, struggles to support life in contrast to some human beings who recklessly destroy it in the interest of controlling land, power, and human labor. She feels strongly that the fate of the Americas has been at risk ever since its conquest by those who exploited its gifts, and that the Quincentennial served only to encourage the land's continuing destruction. By evoking memories of tragic events in America's history, Tremblay implores others to find new ways of living that will support rather than destroy life.

The Things Colonial Angels Witness is constructed as a box that opens on hinges from the center, revealing three inside panels. The center panel illustrates the destruction of the Aztec capital of Tenotchitlan at the hands of the Spanish armies of Hernando Cortes in A.D. 1525. The Aztec deity Quetzalcoatl, the feathered serpent, bleeds as he hovers above the burning city. The panel on the left shows the heartless murder of Atahualpa, the king of the Peruvian Inca who was captured and held for ransom by the conquistador Francisco Pizarro. The Inca people emptied their temples of sacred gold in order to meet Pizarro's demand, but he ordered Atahualpa garroted in the public square of the town after the ransom was paid. The dolls on the right side of Tremblay's piece represent the strangled Atahualpa and one of the temple virgins who was beheaded with him. Behind them, the Spanish melt the ill-gotten gold into ingots using giant caldrons. The left panel of Tremblay's piece represents the destruction of an Iroquois village, one of many sacked and burned by the infamous General John Sullivan during his campaign against the Iroquois during the American Revolution.

Tremblay employed dolls in this piece for the first time in her work, although several pieces with dolls have followed. She meticulously researched the clothing and other details of the events in order to render the scenes accurately. Not visible in the photograph, the exterior of the box offers a more hopeful note. On the back, behind the hinged doors, Tremblay painted corn plants to symbolize the indigenous New World which the conquerors have tried so hard to destroy. These three corn plants become the three corn sisters on the rear of the central panel, young women in modern dress who symbolize survival into the present and hope for the future.

Mixed media.
Collection of the artist.

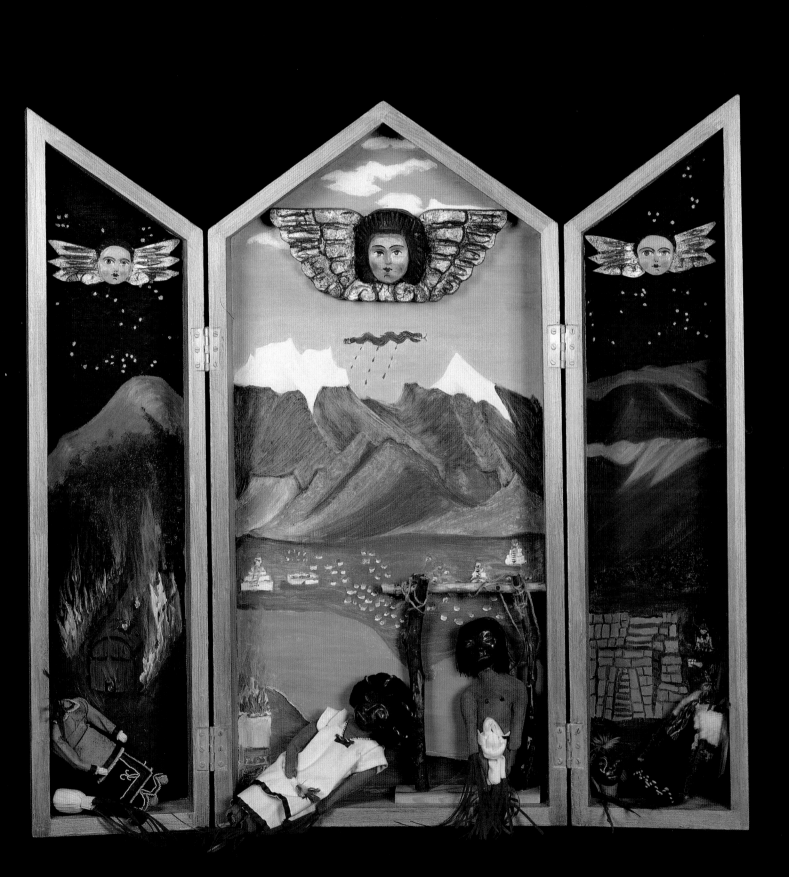

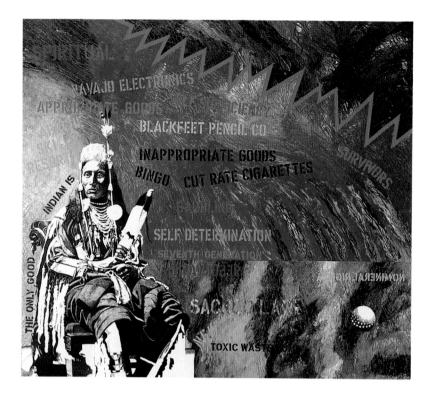
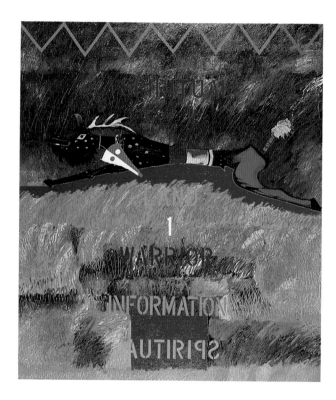

The End of Innocences

George Longfish (Iroquois/Seneca/Tuscarora)

1992

George Longfish, a Seneca/Tuscarora with roots in the Six Nations Reserve, Ontario, trained at the Art Institute of Chicago and now teaches at the University of California at Davis. He is a pioneer painter of Native American ancestry who has always spoken with an independent voice. Like others of his generation who had modernist training, he eschews stereotypical American Indian imagery and instead paints rich abstractions saturated with color and filled with graphic scribings that render traditional symbols and themes using a very personal, visual language. Some works are given ironic, sometimes humorous titles such as *You Can't Rollerskate in a Buffalo Herd No Matter How Strong Your Medicine* (1979). Such a title underscoring the non-representational contemporary appearance of Longfish's work calls attention to the circumstance of being an

American Indian artist in the modern world. It is a condition fraught with ambiguities and ironies, which is sometimes best met in the traditional, time-honored way, with sharp-edged humor.

The recent Columbus Quincentennial inspired Longfish to take a more confrontational, activist approach in his work. He embarked on a series of monumental paintings with epic ambition that function as powerful statements of his political concerns. Each of the three panels of *The End of Innocences* towers ten feet high. The work traveled with the recent *Indigena* exhibition, a show curated by Jaune Quick-to-See Smith that was conceived as an Indian response to the Quincentennial. The panels contain unexpected juxtapositions of images: reproductions of photographs of Medicine Crow and the Man Chief

106

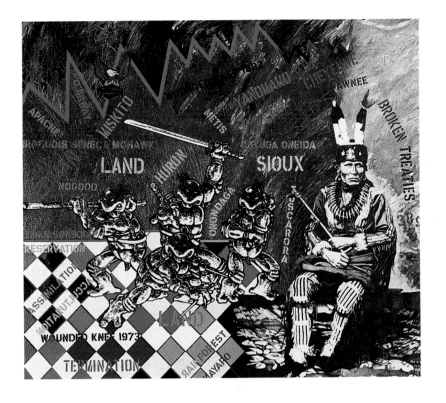

Triptych.
Acrylic on canvas.
Total measurement: 10 x 25 ft.

Panel I: (Previous page, left) *Appropriate Good—In Appropriate Goods. If you play the government game, you get support. If not, no support.*

Panel II: (Previous page, right) *Spiritual Power, Confrontations at Oka, Canada: one death, Natives own their cultural information, revert to fight Elk Society (warriors).*

Panel III: (Left) *Past, Present, and Future History—History Repeating Itself. South America and Rain Forest next.*

taken on the occasion of their visits to Washington, D.C. during the nineteenth century join today's Ninja Turtles, and all are set within an environment charged with electric color. Stenciled words arranged in seemingly random order across the three panels reiterate the themes articulated in the extended titles of each panel.

Longfish has said that the picture tells about the power of owning one's culture. He reclaims, for example, the photographic images of Medicine Crow and Man Chief taken by government-sponsored photographers by incorporating them within the work. The presence of topical cartoon characters halts any attempt to sentimentalize the message. Longfish identifies these warrior turtles with the Iroquois Turtle clan, an idea he credits to his children. The act of appropriating these Ninja Turtles by

transforming them into Turtle (clan) warriors redefines the customary relationship between mainstream culture and those who are acculturated by it. Here, instead of showing how Indians have been absorbed into the white world, Longfish uses popular figures to show how Indian people have appropriated mainstream culture and transformed it to make it appropriate in their world. It exemplifies the manner in which "tradition" in its purest sense functions, by persisting as a culturally rooted filter that interprets the world in its own terms.

Veteran

Ric Glazer-Danay (Caughnawaga Mohawk)

1993

Ric Glazer-Danay was raised in Brooklyn, New York, and worked construction on the high iron, an urban Mohawk tradition. He was also a dishwasher, a bouncer, and worked for Dean Martin as a bodyguard. His fine arts training included studio work that led to a Master of Fine Arts degree from the University of California at Davis. Today, he teaches painting at California State University at Long Beach.

As an artist and a human being, Danay has avoided defining himself too narrowly. Through his work, his writing, his statements during interviews, his whole life, it seems, he has consciously undermined any efforts on the part of others (critics, writers, even his fellow artists) to be categorized. In that skittishness and self-described confusion, there is great freedom of action. Of all things, Danay seems most strongly committed to acts of creation. His painting is informed by the day-glow coloring of pop art, the youthful graphic devices of comic book illustration, and an urbane sensibility filled with humor and irony. Danay says he is serious about humor. His work often confronts stereotypical conventions of American Indian art by drawing on very personal influences and symbolism, no less "authentic" for being unexpected. He claims the right to define himself as an Indian person of the twentieth century with whatever his experience, instinct, and intellect has to offer.

Veteran creates a visionary landscape of vibrant color and near-palpable texture. A massive mountainlike form composed of stalactite and stalagmite drips and stripes in pulsating color rises up to fill the center of the picture. It suggests a primordial landscape, an environment charged with spiritual energy. The "veteran" of the title is pictured in the lower right corner, contained within space filled with starlike dots against deep blue. He is the head male dancer at a contemporary powwow who leads the dancers at grand entry, the resplendent beginning of the powwow when all the dancers parade into the dance ground. Head veteran dancer is a highly honored role and must be filled by a man who has served in the military. The contemporary veteran in dance regalia pictured amidst Danay's timeless cosmo-scape suggests those traditions of Native culture that must be experienced emotionally and spiritually, deep in the soul, at moments like grand entry. As the Gros Ventre writer (and veteran head dancer) George Horse Capture put it, "My body leans forward, tensing, and my descending moccasin sets the bells ringing, my knee comes up higher, and then I am in the arena, dancing in rhythm with all the others, 'shaking the earth.' . . . I am part of the widening circle of dancers, each a living part of the tradition that is Indian."

Acrylic on board with collage.
31 × 43 in.
Collection of the artist.

Feather Canoe

Truman Lowe (Winnebago)

1992

Truman Lowe has spent most of his life in the vicinity of his Winnebago homeland in Wisconsin. Today, he teaches sculpture at the University of Wisconsin, Madison. Like many contemporary artists his work explores ways to bring the traditions and identity of the American Indian into the modern present.

Lowe grew up in a traditional environment where many things were handmade. His elder relations were accomplished basket makers, and his preferred method of fabricating sculpture owes a great deal to the techniques of basketry. Lowe works on a larger scale, however, constructing architectural forms by bending and binding raw wood, techniques which were customarily employed for the construction of traditional Winnebago lodges or homes. By adapting the traditional Winnebago vocabulary of media, technique, and form to the expressive possibilities of modern art, he has derived a very personal language of symbols, using architecture as a kind of personal metaphor for his more amibitious works. Lowe also makes sculpture of cast bronze and more recently has produced several series of vibrant works on paper.

Feather Canoe represents the recurring theme of rivers and flowing water found in much of Lowe's work. His native Woodlands environment is dominated by water: it is present to some degree in all living things and in many areas is particularly plentiful. Even the wood Lowe employs in his sculpture contains water. A recent series of pieces based upon an early experience is related to this theme. While picking berries in a bog as a child, an elderly aunt notched a willow sapling with a knife to provide her nephew with a drink of water. Lowe marvels to this day about the cold, clear fountain of water that flowed from the interior of that tree. Water, for him, has become a metaphor for the life force, the animating power within the earth that flows through and across the land and fills every living thing.

Traditional Woodland canoe construction techniques resemble traditional Woodlands domestic construction. Lowe's fascination with canoe construction is, therefore, not surprising, considering his interest in domestic architecture. Over the last several years he has produced a series of works based on canoe forms. The armature for *Feather Canoe* was assembled by using struts of wood spathe bound together, a method which characterizes many of Lowe's sculptures. The interior of the "canoe" is lined with white feathers, an allusion to the artist's perception that a a canoe on the water travels, in a sense, suspended above the earth: feathers allow a bird mastery over the air just as a canoe allows human beings mastery over the surface of water. Feathers or images of feathers are a kind of personal signature in much of Lowe's work: the feather represents the artist himself and his culturally rooted sensibility.

Wood and feathers.
18 × 72 × 12 in.
Eiteljorg Museum of American Indians and Western Art, Indianapolis, Indiana.

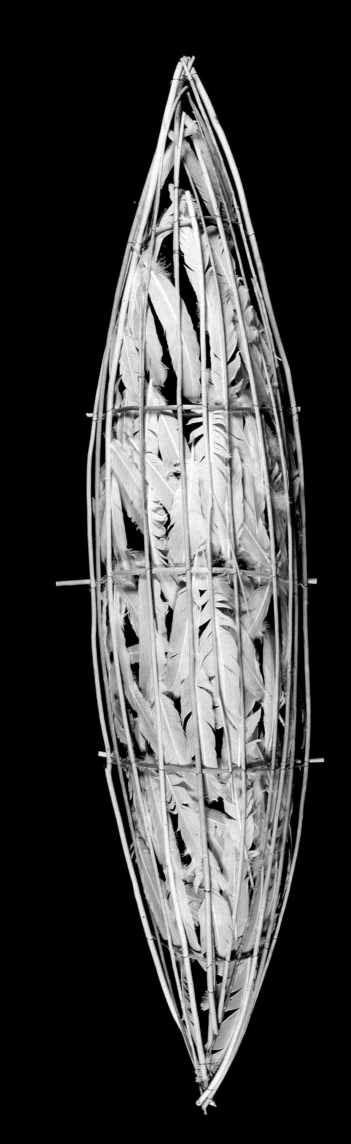

Letting Go: From Chaos to Calm

Kay WalkingStick (Cherokee)

1990

Of mixed parentage, Kay WalkingStick shares the experience of many people of Indian ancestry who did not grow up nurtured within a strong, traditional community. She was born in Syracuse, New York, and was raised there by her non-Indian mother, who constantly emphasized the Cherokee ancestry of a father no longer present.

A great deal of WalkingStick's thought and work has explored the implications of the experience of being a Cherokee person raised outside the community. Her art has helped her to explore that question. After training for a Master of Fine Arts degree at Pratt Institute in New York City—the heart of the contemporary art world during the early 1970s—she became a nonrepresentational minimalist. Her studio training and early career there shaped both her identity as a contemporary artist and the character of her work, which is deeply committed to the formal and spiritual implications of the act of painting. WalkingStick's canvases speak of the process of their own creation, clearly showing marks, scrapings, and layerings that literally trace the movements of the artist's bare hands. WalkingStick is a modernist painter in that the act of making art represents for her a kind of courageous and, when successful, transcendent self-examination. In a larger sense, her work explores the very personal and modern American Indian identity while employing the modernist language of contemporary painting.

The diptych format of WalkingStick's recent work derives from her intuitive exploration of traditional and non-European ways of knowing, and of the relationship between the empirical and the spiritual, the seen and the felt, the known and the unknowable. These are not "either/or" relationships for her, but complementary parts of a unified whole, two sides of the same coin. Both panels of *Letting Go: From Chaos to Calm* represent experiences of nature. On the right side, WalkingStick painted a rushing waterfall in which the thick gestures of paint trace the tumbling courses of water. This is an empirical perception of nature's effects depicted with all its motion and vibrancy. On the left side, an elipse hangs suspended against a cone shaped within a field of scumbled paint. WalkingStick's inner perception of nature employs pure form, color, and texture as an expression of the timeless, greater cosmos in which nature exists. One side is not an abstraction of the other, but the same thing perceived in a different way. It is as if a fleeting truth, the only true wisdom, may be found in the relationship between these perceptions, the liminal space between the empirical and the spiritual. WalkingStick has invested in her perception of this space a modern spiritual sensibility that for her is uniquely "Indian," meaning that it is inseparable from nature and the earth.

Acrylic, wax, oil on canvas.
48 × 96 × 3 ½ in.
Collection of the artist.

Index

Page numbers in *italic* indicate illustrations.

Photo Credits

Copyright © The Art Institute of Chicago 1994, All Rights Reserved: p. 53.

The Brooklyn Museum, Museum Expedition, 1903, Museum Collection Fund: p. 57.

Buffalo Bill Historical Center, Cody, Wyoming: accession no. CP143: p. 39; accession no. CP106, Dirk Bakker, photographer: p. 45; accession no. 1987.93: p. 65.

Cranbrook Institute of Science, Bloomfield Hills, Michigan, accession no. CP151, Dirk Bakker, photographer: p. 27.

The Detroit Institute of Arts: accession no. 81.219: p. 25; accession no. 81.181.1: p. 29; accession no. 1988.27, Marianne Letasi, photographer: p. 43.

The Eiteljorg Museum of American Indians and Western Art, John Grunke, photographer: p. 111.

The Heard Museum, Phoenix, Arizona, Jerry Jacka, photographer: p. 69.

The Herbst Collection, Tony Herbst, photographer: pp. 70–71.

Ohio Historical Society, Columbus, accession no. WL114, Dirk Bakker, photographer: p. 19.

Lovena Ohl Gallery, Scottsdale, Arizona, Jerry Jacka, photographer: p. 73.

Peabody Museum of Archaeology and Ethnology, Harvard University, Cambridge, Massachusetts: accession no. T1221: p. 77; accession no. T1220: p. 81.

Collection of Richard and Marion Pohrt, accession no. T1988.867: p. 33.

The Seattle Art Museum, Paul Macapia, photographer: accession no. 91.1.95: p. 95; p. 97.

Smithsonian Institution: Department of Anthropology, National Museum of Natural History, Washington, D.C.: artifact cat. no. 240915, Dirk Bakker, photographer: p. 23; artifact cat. no. 2130: p. 41.

The Southwest Museum, Los Angeles, California: photo no. CT 127: p. 59; photo no. CT 294: p. 79.

The Thaw Collection, Fenimore House Museum, Cooperstown, New York, John Bigelow Taylor, photographer: p. 99.

Janis and William Wetsman Collection, Dirk Bakker, photographer: p. 83.

Whitman College Collection, Sam Wong, photographer: p. 91.

Yosemite National Park Collection, Robert Woolard, photographer: p. 85.